THE

AMERICAN

IMAGE

THE

U.S. POSTERS FROM THE

AMERICAN

19TH TO THE 21ST CENTURY

IMAGE

An Exhibition
of Posters
from the Collection of
Mark and Maura Resnick

By
Mark Resnick
with an essay by
R. Roger Remington

Rochester Institute of Technology
College of Imaging Arts & Sciences
Bevier Gallery
Rochester, New York

September 9
through
October 11
2006

RIT CARY
GRAPHIC ARTS
PRESS

The
American Image
U.S. Posters
From the 19th to
the 21st Century

RIT Cary Graphic Arts Press
90 Lomb Memorial Drive
Rochester, New York 14623-5604
http://library.rit.edu/carypress

The views expressed in this work are those of the authors
and do not necessarily reflect the positions of
Rochester Institute of Technology.

All posters are provided courtesy of the Resnick Collection,
except posters **24**, **25**, **29**, **30**, **34**, **74**, provided courtesy of RIT,
and poster **61**, provided courtesy of Bruce Ian Meader.

Printed in the United States
ISBN-10 1-933360-16-X
ISBN-13 978-1-933360-16-4

DESIGNER	Bruce Ian Meader
PRODUCTION	Amelia Hugill-Fontanel Marnie Soom
TYPEFACES	Adobe Minion & Minion Expert, Futura, Univers
PHOTOGRAPHY AND COLOR SCIENCE	Nitin Sampat, Nicholas Duers, Lindsay Dill RIT School of Photographic Arts and Sciences, CIAS
PRINTING	Hewlett Packard Indigo Digital Press (text) Heidelberg Speedmaster SM 74 (cover) John Dettmer, Barbara Giordano, Dan Gramlich, Tim Richardson, Jeremy Vanslette RIT Printing Applications Laboratory
PAPER	Mohawk Superfine Ultra White Smooth i-Tone 100 lb. text Mohawk 50/10 Ultra Blue White Matte 100 lb. double thick cover

CONTENTS

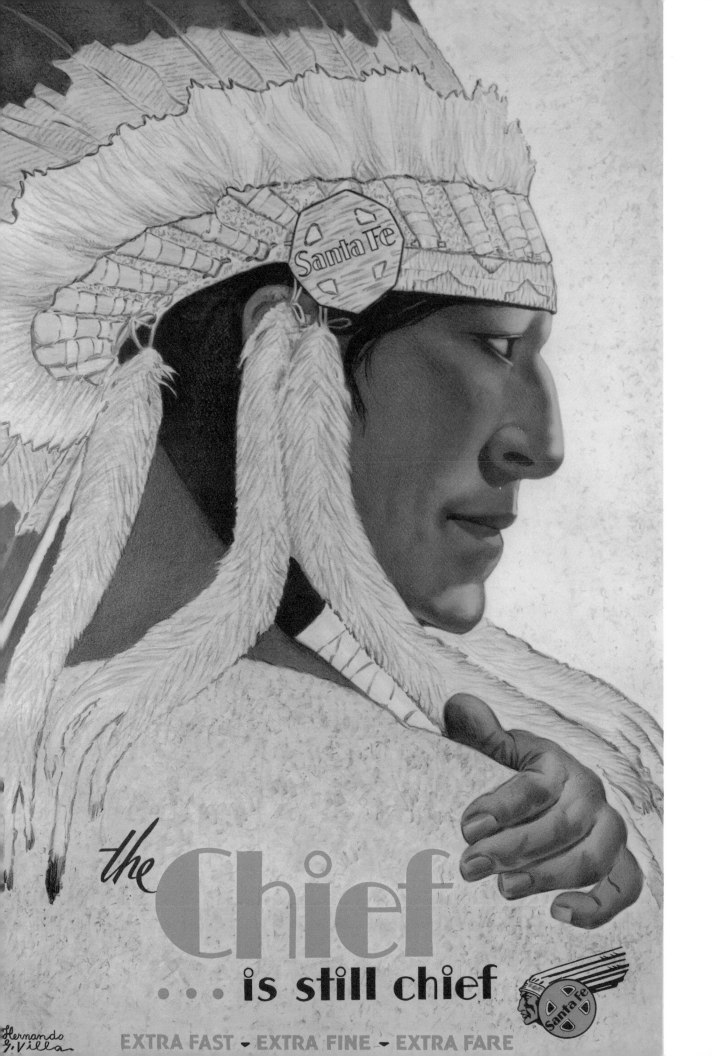

PREFACE

Mark Resnick

Professor R. Roger Remington asked me to write this preface, regarding my background as a collector, the focus and goals of the collection, and the exhibition this book documents. Roger believed such a preface would shed light on collecting in general—what makes collectors "tick"—and on this collection in particular. I agreed, considering it an opportunity to reflect on my rather fanatical pursuit of American posters.

∼

Probe an adult collector and you will usually find someone who collected as a child. I collected the things kids typically collect: baseball cards, coins, stamps, and so forth. I also collected art reproductions and contemporary posters.

Most serious collectors satisfy and express multiple passions in their collecting; again, I am no different. From childhood I loved looking at art, making drawings, and writing. As combinations of image and text, posters matched my interests perfectly. (I should note that my visual orientation came from my mother; and under my physician father's influence, I focused on science and made anatomical drawings, thinking I might become a doctor and medical illustrator.)

College presented a bit of a dilemma: Yale has great science and liberal arts programs and I was interested in both. As it turned out, I completed the pre-med program but majored in art history. I studied Western art intensively but became even more interested in African art history, intrigued by its emphasis on anthropology and contextual analysis (a logical emphasis given how integral tribal art objects are to the tribe's daily life). Similarly, I became interested in the role of art in popular Western culture, and in art that is more significant politically, socially, or culturally than aesthetically. The debate was then quite hot between context-oriented and object-oriented art historians (the "deconstructivists" versus the "connoisseurs"), but I was happy just to get a good dose of both approaches.

1 Paul Von Blum,
 The Critical Vision:
 A History of Social
 and Political Art
 in the United States
 (Boston: South End Press,
 1982).

2 The purpose of my
 comparison of fine art
 with posters is not to
 question fine art's
 standing. I am simply
 advocating that we
 pay serious attention
 to an area of the
 visual arts too long
 regarded as ancillary.

Law school did not leave me much spare time but I jumped at an opportunity to edit and contribute to *The Critical Vision: A History of Social and Political Art in the United States.*[1] In addition to fine art, the book examined popular media, including posters. After my first year of law school, I decided I wanted to practice entertainment law, envisioning it (semi-accurately) as a marriage of art and commerce. I was lucky enough to get work in the movie business right out of law school, in the early 1980s.

By 1990 I was fairly settled into my career as a movie studio executive and lawyer, and started, on a small scale, to collect vintage posters. At first I collected French posters but quickly gravitated to American. By the end of the 1990s I was acquiring numerous posters each year. I learned as much as I possibly could, by viewing a huge number of posters, voraciously reading and collecting graphic design books, attending the all too rare poster exhibitions at galleries and museums, and forging relationships with dealers, auctioneers, scholars, and other collectors. In recent years, while continuing this education, I have acquired fewer posters but aim for top quality.

~

Why I collect posters is largely answered above: at the intersection of art, commerce, and popular culture, they are a close fit for my interests and background. I also want to help reverse the second-class treatment posters are given in the art world.

But there are other questions to address briefly: What accounts for the lesser status of posters among art aficionados? Why collect *American* posters in particular? What are the criteria for building the collection and what are its goals? What are the biggest challenges?

The Status of Posters in the Art World

It is pretty clear that posters owe their second-class status to not being considered "fine art"—and thus not being eligible for that rarefied market. To oversimplify: *Fine art* tends to be inaccessible, exclusive, and elitist; to be long-lasting; and to lionize the artist. *Posters* tend to be accessible, inclusive, and populist; to be ephemeral; and to underplay the designer, whose role in the work's creation is often unknown or unacknowledged. The first set of characteristics enhances the market, while the second does the opposite.

At the risk of further oversimplification, the relative inaccessibility of fine art and accessibility of posters might be broken down as follows:[2]

	Fine Art	Posters
STYLE AND SUBJECT MATTER	Form and aesthetics are often emphasized over content, abstraction over realism, and "high," beautiful subjects over "low," topical, or unattractive ones. Commercial or overt "messages" are generally avoided.	Content and realism are usually the priority, to reach a mass audience.[3] Subjects are often topical, based on the realities of daily life. Conveying a message–commercial, political, etc.– is imperative.
QUANTITY AND PRICE	Limited quantity is preferred, driving higher price. A "culture commodity," the work is *made* to be sold and at the highest price the market bears.	Usually mass produced. Not intended primarily for sale or collection, the work is free or low-priced to encourage access.
DISTRIBUTION	Typically distributed by a specialized network of art dealers and auction houses.	Typically distributed outside the fine arts network, via grass-roots or commercial channels.
OWNERSHIP AND DISPLAY	Privately owned and seen by few, or museum-owned and viewed in that special environment.	Even if commissioned by private interests, the work is publicly displayed, often in the street.
CONNECTION TO CRITICS	Often requires explication and validation by established critics, curators, academics, and dealers–the "high priests" who help to sustain and determine the market.	Fewer high priests are involved because the work requires less explication, graphic design scholarship is a relatively young art historical field, and the market is smaller.

3 This is not to say posters aren't artistic. To the contrary, effective posters are almost always quite distinctive formally, and make excellent use of metaphor and symbol. (See, e.g., posters **30** and **49**.)

4 Significant American antecedents include large woodcut circus posters from the 1850s. These influenced the Frenchman Jules Chéret, renowned as the first practitioner (commencing in the latter 1860s) of the artistic, color lithographic poster.

5 For purposes of the collection, a designer is "American" if he or she is born or does substantial work in the U.S.; and his/her poster is "American" if made in the U.S. or for a U.S. client.

6 The collection somewhat emphasizes modernist posters over more illustrational or "decorative" work. (For a comprehensive discussion of U.S. modernist graphic design and its stylistic hallmarks, see Professor Remington's *American Modernism: Graphic Design, 1920–1960*.) But this is not to denigrate the strong American tradition of illustrational posters, of which there are many outstanding examples in this book.

7 Alain Weill, *The Poster: A Worldwide Survey* (Boston, G.K. Hall, 1985), 72–73.

Why Collect American Posters in Particular?

First, there is their American-ness. I can easily relate to them as products of my own culture and as compelling documentation of my country's history. Many have a distinctively American quality, a vernacular appeal. (See, e.g., poster **12**.)

Second, American posters compare quite favorably to those of other countries. European posters, for example, are justifiably prized for their long history, avant-garde tendencies, famous images by "big name" designers, and brilliant execution. Yet:

- "Modern" American posters have an important history dating to 1890 and earlier.[4] From the outset, such designers as Will Bradley, Edward Penfield, and Louis Rhead created masterful posters that were influential and eagerly sought throughout Europe. (See, e.g., posters **1**, **2** and **3**.)

- American designers[5] were certainly avant-garde. Lester Beall and Edward McKnight Kauffer were joined by others in creating a trove of "modernist"[6] posters. (See, e.g., posters **22**, **24** and **50**.)

- There are plenty of famous American posters by big name designers. (See, e.g., posters **21**, **36**, **56**, **58**, **59**, and **72**.) Then again, American designers were frequently brilliant in their *anonymity*. (See, e.g., posters **11** and **23**.)

- On the technical side, the early American lithographic firm, Strobridge, was a world leader and the United States "was most certainly where the poster had developed furthest."[7] And during the Depression a poster designer working for the Federal Art Project (FAP)—part of the government's massive work relief program—"invented [and named] a new medium: the serigraph, later used for fine-art prints by countless artists."[8]

Finally, because American posters have been somewhat less collected, studied, and documented than posters of other countries, they present distinct opportunities. To begin with, top pieces are somewhat more available (and were more affordable, until the market acceleration of the last few years). Also, American posters require deeper research, which, especially given my art history background, I enjoy. More fundamentally, I can make a real contribution to the field simply by systematically collecting, preserving, and documenting these posters as a unit, as that has rarely if ever been done.[9]

8 Anthony Velonis "adapted the industrial silkscreen process– already used for printing commercial displays and banners–for high-volume, multicolor poster production." Carol Strickland, "Posters for the People," Civilization 4 (1977): 66–75. FAP designers used silkscreen printing because it was relatively straightforward, fast, inexpensive, high-impact, and beautiful due to its color saturation.

9 Active poster collectors also contribute to the field through market participation: a strong market encourages preservation and the emergence of long-lost posters and designers.

10 This defies the conventional wisdom that "true" or "great" collectors essentially ignore fiscal considerations. My guess, however, is that such collectors are either quite wealthy (bless them) or collect in a field where prices are still relatively low.

The Collection's Goals and Challenges

As the above suggests, the primary goals of the collection are to represent the history of the modern American poster and to stimulate greater awareness, study, and esteem of these works. Achievement of the first goal requires assembling a museum-quality, broad archive. Achievement of the second requires sharing the collection. I am happy to do exactly that–hence this exhibition and book.

The most significant challenges I face in building the collection are finding free time and discovering exceptional, reasonably-acquirable material. As to time, it is a tall order to balance a commitment to family, a very busy job, and several significant interests besides graphic design. As to material: finding a particular excellent poster is hard enough; but finding and funding an archive's worth of posters is another story altogether. I must be very selective and (over)do my homework; forego even great posters if their price is too high;[10] buy "good" posters only occasionally, and with even more caution about price; and be disciplined about auctions, even though they may be the only source for some posters. The bottom line is this: achieving the collection's ambitious goals requires a combination of a sharp eye, deep knowledge of the material, and solid business skills; so that is the "recipe" I try to follow.

~

I should also note some background about the exhibition itself. I got to know Roger, a leading authority on American graphic design, through my collecting. The exhibition grew out of one of our many conversations. Frustrated about being too busy to write in the field–and thus not sharing the collection–I asked Roger's opinion about having an exhibition. He felt strongly that it should happen, and at RIT.

Given the collection's scope, Roger and I agreed that the exhibition would survey the long history of the modern American poster. It would fill a void, as there have been almost no such survey exhibitions. To reduce the collection's several hundred posters to an "exhibition group" of about 75, Roger and I each made a list of selections. Posters that appeared on both lists would automatically be exhibited. Posters that appeared on only one list would be winnowed with these criteria in mind: the poster's effectiveness and aesthetic merit; its historical, social, political, or cultural significance; how well it represented a significant style or designer; and whether, to our knowledge, it was ever exhibited.

The group of posters that finally emerged from this process has a broad range: from design masterpieces to works of greater historic than aesthetic value; from posters created by celebrated designers to those made by little-known or even unknown designers; and from often-reproduced images to those that are seldom if ever seen.

11 But even in periods of "decline," the anonymous, highly-skilled craftsmen of America's large printing firms continued to churn out posters. They did so through much of the 1930s and a number of their posters were extraordinary. Also, posters from the 1980s to the present that reflect Post-Modernism and the rise of digital graphics are underrepresented here; they are a fertile ground for a subsequent exhibit.

Survey exhibitions are overly ambitious by definition. In addition to logistical challenges due to the exhibition's scale, there are always "gaps" to worry about. Some of the missing designers we would love to have included are Lucian Bernhard, Michael Bierut, Will Bradley, Seymour Chwast, Louis Danziger, David Lance Goines, Maurice Logan, Sascha Maurer, Leslie Ragan, Ethel Reed, Massimo Vignelli, and several of the so-called "rock artists." And some of the categories we wish we had room to cover are the "stock" posters produced by America's large, early printing firms (i.e., generic posters adaptable for local events and attractions); the "work incentive" posters of the 1920s and '30s; posters relating to disease awareness and eradication (e.g., tuberculosis, polio, and AIDS); and sports/Olympics posters. Although these designers and categories are generally well-represented in the collection, restricting the exhibition to about 75 posters meant that they could not be included here.

It should be noted, however, that apparent *time period* gaps in the exhibition actually reflect periods of diminished or less noteworthy poster-making. This is the case during the decade or so before and after World War I, during much of the 1950s, and during the first half of the 1960s (with the decreased output of the latter periods reflecting the ascendancy of newer advertising media). In other words, the exhibition is representative of American posters' periodic flowering and decline.[11]

≈

In acknowledging those who made this project happen, I would like to start with Professor Remington. A relationship that began with my cold-calling him to ask a question about Lester Beall has truly evolved and flourished. I am grateful for his scholarship, leadership, enthusiasm, and perseverance. He has been the driving force at every turn–by helping to organize the exhibition, writing the essay at the beginning of this book, co-designing the book with Professor Bruce Ian Meader, helping to fundraise, and being a tireless liaison to many other areas of the university. Even more, he has been extremely generous to me in every aspect of our work. He has made me feel like a true colleague and made the project a model of cooperation between "town and gown."

12 As just one example, RIT's Cary Graphic Arts Collection and its Graphic Design Archives, which cover the 15th through 20th centuries, are world-leading repositories that support a broad range of graphic design scholarship.

13 Collectors inspire collectors. I am amazed by the accomplishments of Merrill Berman, Leonard Lauder, Les Schreyer, and Mitchell Wolfson, Jr., pioneers in the collection of posters and other graphic design.

Nor could I have found a better home for this project than RIT. Not only is the School of Design one of the nation's best, but it is unsurpassed in its emphasis on preservation, history, theory, and criticism.[12] RIT has been able to ensure a first-rate exhibition and book, through its Bevier Gallery, under the leadership of Betsy Murkett; its Cary Graphic Arts Press, headed by David Pankow (who is so ably assisted by Amelia Hugill-Fontanel and Marnie Soom); its superb resident designers such as Bruce and Roger, who gave this book its remarkable form; its administration, especially Associate Dean Frank Cost and Dean Joan Stone of the College of Imaging Arts and Sciences, whose support and wisdom kept this project "on the rails" at several difficult junctures; its School of Photographic Arts and Sciences, especially Professor Nitin Sampat who carried out the image reproductions; its Printing Applications Laboratory for the book production; and, finally, its School of Design Advisory Board, whose members have been generous in their support.

I have also been fortunate to work with some extraordinary dealers. Not middlemen but collaborators, they shared their knowledge and judgment and had a major impact on the collection: Robert Chisholm, Jim Lapides, Susan Reinhold, George Theofiles, and, especially, Steve Turner. I have also benefited from working with outstanding auctioneers: Nicholas Lowry of Swann Galleries, Jack Rennert of Poster Auctions International, and Joern Weigelt of Poster Connection.[13]

Having said all this, the collection would not be one without the collection management talents of Ron Steelman and Lauren McDaniel. Ron expertly laid the collection's organizational foundation (databases, image banks, insurance, etc.). When Lauren took the baton from him, she was thus able to focus more on this project, using her librarian and art history background to great effect in helping me with the text appearing later in this book—all while seamlessly handling a multitude of logistical matters.

I would also like to recognize friends and advisors, within and outside the design community, who have supported this project and for years put up with my yammering about posters: John Clark, Tom Jessor, Michael Kleeman, Stephen Marmer, Daniel Ostroff, Lee Rosenbaum, and Michael Yanover.

Last, but definitely most, there is my family. My collecting has encroached on family time—and never more so than during this lengthy project. Yet my wife Maura is unfailingly supportive, is enthusiastic about the collection itself, and always has great insight. She is also a superb editor, and her skill is evident throughout this book. Ethan and Aaron (our children, ages 13 and 10) are likewise quite interested in the posters and especially in the collection-building process—always wanting to know about the "hunt" and the "deal"! My exceptionally caring, remarkable family does more than indulge my obsession—they make the experience far more enjoyable and the collection far better. I love them and I thank them.

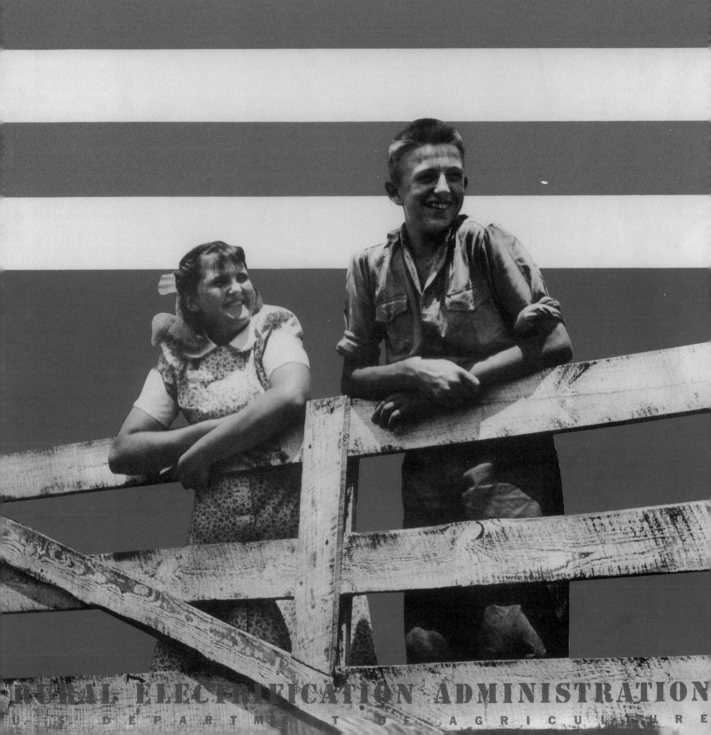

RURAL ELECTRIFICATION ADMINISTRATION

U. S. DEPARTMENT OF AGRICULTURE

R. Roger
Remington

Ugliness is a
form of anarchy
that should be
stamped out
Lester Beall

A Mirror of History

Many media forms leave behind a residue or an indexical record which provide us with a look back at history. Now one can sit in front of the television every evening and watch via cable the History Channel for hours as the battles of World War II are fought again and again. Recently USA Weekend was offering an "exclusive" subscription of posters of the Harry Potter characters. Or one might stop by Barnes and Noble and, while browsing, become taken by a thick book about the Civil War. An aunt's attic may hold treasures such as old postcards which take us to exotic places in the world. While surfing channels on cable television, a movie about Shakespeare might grab our attention. Or in school, a history course might be available to provide a sense of the past. Today, while walking on the street and viewing messages on the fly, it is possible to obtain an educated context for contemporary history.

Any and all of these media forms give us information about what has gone before. Each form, in its own way, mirrors the past. The printed poster can afford an indirect view of the past and can document events in many genres. These "graphic traces" from the past are compelling and memorable in that, through their indirect references, they draw us into the process of perception, thus becoming more involving and memorable. They show us the culture of a society, the state of its printing technology, its customs, dissenting viewpoints or dominant ideologies, commercial products being consumed, aesthetic style, and those "social powers" which influence individuals, from politics to institutions, from fashion to slang. We see specific references made to events in government and politics, entertainment, changing styles, environment, safety, popular culture, advertising, war and propaganda, travel and transportation, commerce, world's fairs and many other subjects. Posters, when displayed before us, create a provocative panorama of detailed history looking back at us. They help to bring history alive.

1 Stewart Wrede,
The Modern Poster
(New York:
The Museum of
Modern Art), 1988, 13.

"The poster, a medium of its time, has always existed at the junction of the fine and applied arts, culture and commerce. As a hybrid medium it has provided an arena where painting, drawing, photography, and typography came together in new ways, influencing each other in the process."[1] Posters are usually large in format, colorful and bold. They take us on a journey through events that create, in our collective viewing, a dramatic and immediate gestalt of history, one that television or film is incapable of realizing in the same way. Author Max Gallo has written, "The function of the poster today is to appeal to our subconscious feelings and our barely conscious needs and then channel them so that we do what the sponsor of the poster wants us

2 Max Gallo,
The Poster as History,
Reprint Edition
(New York, London:
w. w. Norton & Company,
Inc., 2002), 10.

to do."[2] In real time, this communication situation is unique among media forms in that the poster grabs our attention and holds it long enough to deliver its message. Other types of media have their own patterns of immediacy and processing. Therefore posters reflect the past, sometimes distorting history but, in the end, revealing meaning to us in a dramatic way.

The European Influence on American Posters

To understand the development of the poster in America, it is important to first establish an historical context on a global scale. The Modernist poster made its debut in Paris, although Jugendstil (German Art Nouveau) posters already had a dramatic presence in Berlin and Munich. In Europe, even before the Industrial Revolution, advertisers in England, France, Germany and Italy had found the poster to be an effective means of reaching their markets. "The medium of print—or typography—in books, journals, newspapers, posters, broadsides and advertising was one genre of artifact that proliferated, as the principal means of creating markets for new products."[3]

3 Wrede, 11.

Colorful, large format posters promoted cultural events such as the theatre. These posters were printed by stone lithography, which meant that the artist had to draw and paint by hand, in reverse, all illustrations or lettering. The first exhibit devoted exclusively to the poster was held in Paris in 1884. There the posters of Henri de Toulouse-Lautrec and Jules Chéret were seen throughout Paris. A legend persists that these artists were so recognized and appreciated that often their posters were removed by citizen-collectors as soon as they were put up. Posters were also used for advertising products and other commercial merchandise. Many styles were evident and were seen as satirical, artistic, romantic and even comic.

The good poster may be compared to a well-selected fly cast by a skillful angler who knows his particular fish.

E. McKnight Kauffer

The 1920s and 1930s were a high point of the poster in Europe. Beginning with origins in Art Nouveau, the Arts and Crafts movement and Jugendstil, many European countries developed quite different styles. In Germany, the posters of Ludwig Hohlwein and Lucian Bernhard foreshadowed Modernist values in their simple, direct and information-oriented approach to design and advertising. Following the creative breakthroughs of art movements such as Cubism, Expressionism and Surrealism, the artists, writers and designers of the avant-garde spearheaded the way to a new visual vocabulary. "The development of a new way of seeing that cultivated their unexpected, chance juxtaposition of images, the viewing of objects out of their familiar contexts, and the layering of disparate images was fundamental to the new aesthetic of the first decades of the twentieth century."[4] These effects were as evident in the posters of the time as they were in the art, writing, book design, typography, and advertising of the era.

4 Ibid, 12.

Posters reflected the radical forces at work in the culture. Other avant-garde movements such as Dada in Germany, Futurism in Italy, de Stijl in Holland, Constructivism in Russia and Purism in France led the way in breaking down traditional forms of message making and creative expression. The Bauhaus in Germany consolidated many of the arts of the 1920s and 1930s and, in its Dessau phase, played a major role in combining the formal vocabulary of the avant-garde groups with the applied arts. László Moholy-Nagy, Joseph Albers, Oskar Schlemmer, Herbert Bayer and Joost Schmidt were teachers who created important posters at the Bauhaus. Bayer's posters for a Poelzig lecture and a Kandinsky art exhibit represented the full maturity of the Bauhaus graphic style.

The purpose of a poster is to seduce the eye then address the intelligence.

El Lissitzky

El Lissitzky, the Russian designer/artist, became the greatest single artistic influence during this period. Beyond his exceptional work in Russia, he traveled extensively in Europe, spreading his Constructivist ideas to other avant-garde artists and designers. At the same time he was assimilating new ideas from his colleagues. His poster *Beat the Whites with the Red Wedge* remains a classic as an early, completely abstract poster. It refers, in symbolic form, to the political situation in Russia during the Russian Revolution. His great exhibition poster from 1929 exemplifies the promise of youth and the pervasive Utopianism of the Russian Revolution. Also in Russia, the Stenberg brothers, working in tandem, created extraordinary film posters in the 1920s, especially for film maker Sergei Eisenstein. What characterizes these great film posters is their fusion of avant-garde visual form and popular culture.

Between the world wars, Paris was the crucible of creativity. Léger and the Purist painters, particularly Ozenfant and Le Corbusier, were the primary influences on art forms and graphic design. A. M. Cassandre's posters expressed the euphoria of the new hectic pace of life and the new freedom in the industrialized middle class. His poster for Triplex glass combined the commercial with the aesthetic, and his *La Route Bleue* and *Étoile du Nord* symbolized the appeal of fast travel by railroad. Other French artists such as Jean Carlu, Paul Colin, Charles Loupot and Pierre Fix-Masseau also contributed classic railway posters. E. McKnight Kauffer was Cassandre's counterpart in England. Born in the United States, Kauffer immigrated to England and there became its leading poster designer. His posters for the London Regional Transport Authority regularly presented the lure of travel in the beautiful English countryside. What makes the posters of Cassandre and Kauffer so powerful is their reduction of complexity to basic information essentials. Influenced by the Purist painters, they both intuitively applied the formal visual language of the Modernist movement.

With the new canvas… the culture of painting no longer comes from the museum. It comes from the picture gallery of our modern streets— the riot and exaggeration of colors on the lithographic poster.

El Lissitzky

After 1920, artists and designers in Switzerland adopted a style which extended the earlier work of Lucian Bernhard. Herbert Matter's classic Swiss travel posters from the 1920s, *All Roads lead to Switzerland* and *Pontresina*, exemplify dramatic size contrast with the powerful integration of photography and photomontage. In London, Abram Games was influenced by Cassandre and Kauffer, becoming England's most prominent poster artist during World War II. Born in Germany, Hans Schleger, who signed his work "Zero," was a contemporary of Games in London during this period, and made memorable posters, advertising and corporate design programs.

Following the devastation of World War II, more traditional taste returned to the world of poster design. The lyrical abstraction of French artist Henri Matisse and the biomorphism of Joan Miró dominated European posters of the period. Tom Eckersley and F. H. K. Henrion were designing notable posters in Great Britain, while Franco Grignani, Bruno Munari and Giovanni Pintori were using the medium well in Italy.

Bauhaus and Constructivist influences maintained their new hold on post-war America and in Switzerland. The Swiss consolidated and extended this formal and functional trend, exemplified in the 1950s by the wide use of the typeface Helvetica, due to its clarity and legibility. Two designers who emerged from this milieu were Armin Hofmann in Basel and Josef Müller-Brockmann in Zurich. Hofmann's great poster of *William Tell* and Müller-Brockmann's *Musica Viva* series embodied the application of Swiss formalism to poster design.

In post-war Poland, the circus, theatre and surrealistic themes dominated a flourishing decade for the poster. Both artists and designers used the poster as a medium for the expression of their views of social, political and cultural issues in both direct and indirect ways. Henryk Tomaszewski was the spiritual leader of this movement which also included artists such as Swierzy, Lenica, Starowiejski and the Surrealist Roman Cieslewicz. Of particular note is the poster *NIE!* by Tadeusz Trepkowski from 1952, which shouts for an end to war with very few visual elements. On the other side of the world, Japanese designers such as Yusaku Kamekura and Ikko Tanaka set the standard for Constructivist-influenced poster design. Later in the 1960s Tandori Yokoo used counterculture and pop art forms, while Shigeo Fukuda produced posters filled with perceptually-ambiguous figures.

A poster is, and must be before everything, a medium of publicity and do its duty as such, whether art is called in or not.

Jean Carlu

In Europe during the 1960s, Swiss designer Wolfgang Weingart produced experimental posters that created new conventions and tested the boundaries of formalism in graphic design, providing what would soon become in America a "new wave" style. Weingart, a German, studied at the University of Basel and remained there to teach with Armin Hofmann. Going against the grain of the Swiss formalist tradition (simplicity, order, clarity and legibility), Weingart replaced it with complex graphic forms that demand detailed study and attention, a style not usually associated with the practical function of poster design. His graphic ideas were soon to be assimilated into the larger post-Modern movement in graphic design, architecture and other creative media.

The Poster: Origins and Beginnings in America

The word poster is an abbreviation of "posting bill" which is said to have come from a custom of attaching notices to posts on the streets of London. In America the tradition was continued as bills were posted on fences, trees and walls, many to promote lotteries. Posters moved inside to the country inns where travelers and locals would gather to socialize, and became a means of advertising auctions, the circus, stagecoach schedules and theatres. Posters even became dimensional and kinetic, as in the 1820s, when it was common to find men on the street wearing sandwich boards.

Eventually the penchant for advertising through newspapers, magazines, handbills and trade cards meant that the poster as an advertising medium would have serious competition. During the 1840s, the first companies devoted to printing posters emerged and were called "poster houses." They were located mainly in Boston and New York. By the 1860s posters had come of age, and 275 firms were dedicated to creating them. The fact that printers could specialize in this way also meant that the printing industry was growing. The technical limitations of the printing process led to an emphasis on the use of words to sell products. America was the acknowledged pioneer in the illustrated poster. However, influence from Britain and France brought about the popularity of the "art" poster in the 1890s.

Posters are produced in many sizes, but usually the larger they are, the more attention they capture. In the United States there has been a tradition of creating large-scale posters, otherwise known as signs, billboards, or outdoor advertising. This movement began around 1925 when gas stations and other establishments along the highways erected signs to alert motorists to coming venues. One of the more famous examples of early advertising of this kind was the signs for the Burma Shave brushless shaving cream created by Allan Odell. He wrote witty rhymes and they were revealed, always in a sequence of five, as the traveler drove along the highway. For example:

> Her Chariot Raced
> At Eighty Per
> They Hauled Away
> What Had Ben Hur
> Burma-shave [5]

5 Grant's Central Station, "Grant's Tribute to the Burma-Shave Sign" http://grantmcl.tripod.com/bshave.html (accessed May 8, 2006).

Historically, environmentalists have frowned on the outdoor advertising poster as pollution of the visual environment. By 1965 this kind of criticism resulted in Congress' passing Lyndon Johnson's—and Ladybird Johnson's—highway beautification bill. Even with this limitation, the outdoor poster continues to fulfill its purpose as an advertising medium across the land, and Times Square in New York is more dynamic, kinetic and colorful than ever.

In spite of its checkered career in America, the poster has caught the attention of many of America's outstanding artists, illustrators and graphic designers. Looking back to the late 1800s, American artists like Will Bradley, Edward Penfield and c. b. Falls were creating posters comparable to their European counterparts. Many outstanding American posters advertised transportation options such as bicycles, trains and even the Boeing Clipper airplane. In 1895 Edward Penfield's poster for *Orient Cycles* and Frederick Winthrop Ramsdell's *American Crescent Cycles* reflect this interest in speed and movement. Magazine publishers used the medium to promote their businesses: Maxfield Parrish's poster *The Century* and Edward Penfield's *Harper's October* demonstrate turn-of-the-century style in American illustration. With the coming of the First World War the poster found its place as the most effective means for government and political organizations to get messages across. James Montgomery Flagg created the classic World War I recruiting posters *I Want You* and *Be a Marine*. Also during the great "war to end all wars," an early graphic extolling the powerful role of women was Adolph Treidler's *For Every Fighter a Woman Worker*. But although the creative talent was ready and willing, the scions of business and industry usually preferred newspapers, magazines and other marketing media rather than the poster for advertising.

Our primary device is montage... but we do not neglect construction. Ours are eye-catching posters which, one might say, are designed to shock. We deal with the material in a free manner... disregarding actual proportions... turning figures upside-down; in short we employ everything that can make a busy passerby stop in their tracks.

Vladimir Stenberg

Poster art flourished in the United States despite the economic Depression. Chesley Bonestell's 1930 poster New York Central Building referred to the recent building boom in New York with a moody yet dramatic night view of this key building on the skyline. It also suggested the great love of Americans to travel. The French cultural icon Jean Cocteau wrote,

> The travel-poster … became a door left open, left indiscreetly ajar, on invitations to travel for which Baudelaire's poem is the lasting model. It was not any more a question of attracting the attention of a crowd to a singer or a guitar-player, to a toothpaste or a car. The travel-poster had to nudge the passer-by and to lead him on towards his own dream, to awaken the need which every human being carries within himself to leave himself behind, it had to put him in a state of hypnosis and to murmur into his ear: Surmount the obstacle of your laziness, dare, roll or fly. This poster is only like a curtain for the sights waiting for you to be seen. It only depends on whether it will raise and whether you will penetrate into what it represents … Break through this paper-frame, through this window of paint and with the instantaneity of the dream you will be able to play the role you want on those scenes which had seemed inaccessible to you.[6]

6 Jean Cocteau, "Das Reiseplakat; Travel Posters," *Gebrauchsgrafik* (1946): 44.

The railroads used the poster medium for their promotional purposes. *The Chief … is Still Chief* by Hernando G. Villa was a classic poster for the Santa Fe railroad, whose motto was "Extra Fast-Extra Fine-Extra Fare." William P. Welsh's poster for the Pullman sleeping car advertised that one could travel in comfort when "vacation lands are calling."

The poster is a powerful weapon in government campaigns to change habits of a nation.
Eric Newton

These years were also marked with strong political and social agendas. Hugo Gellert's 1924 poster *Vote Communist* called for support for "the party of the class struggle." Another poster for this cause was the anonymous *2nd u.s. Congress Against War and Fascism* from 1934. In the 1930s, communicating information about the National Recovery Act was the patriotic thing to do. Store windows proudly displayed their NRA–*We Do Our Part* posters, designed by the pioneering American art director Charles Coiner. This poster represented a first, namely a commercial advertising designer donating his creative talent in order to promote a government program.

To support artists the federal government began a public works art project or Works Progress Administration (WPA), in which unemployed artists, photographers, writers and designers were hired to produce creative methods of promoting cultural and other civic events. Within the WPA were the Federal Arts Project and the Federal Writers Project, among others. The FAP pioneered the artistic use of silkscreen printing, and many WPA posters were reproduced by this stencil reproduction method. Dorothy Waugh was one of the outstanding poster artists to emerge from this period and one of the select women designers of her time. Her poster *National and State Parks* promoted the American national parks system. Ben Shahn, a WPA artist and photographer, produced posters that reflected the difficulties facing Americans. His *Years of Dust* poster from 1936 gave many Americans a dramatic look at the hardships of life in the Midwestern dustbowl.

Urban public space is a stage for viewing the field of graphic design in its diversity. A mix of voices from advertising to activism compete for visibility.

Ellen Lupton

WPA posters could be found in every public building during the Depression. There were even posters advertising WPA posters. In Chicago, the graphic *Poster Exhibit* evidenced Modernist influences in its simplicity. The Civilian Conservation Corps (CCC) was another government program that put people to work, building parks, roads, and other infrastructure. Robert Muchley's monochromatic poster *Work with Care* was a bold statement of America's work ethic. In a similar manner, Albert M. Bender's CCC *A Young Man's Opportunity* suggested a glimpse of optimism during these dark days.

7 Leon Friend and Joseph Hefter, *Graphic Design: A Library of Old and New Masters in the Graphic Arts* (New York: McGraw-Hill Book Company, Inc.), 375.

In 1936, Leon Friend and Joseph Hefter, in their book Graphic Design, proposed this formula for an "ideal" poster, "Decoration is combined with lettering to produce a unified design that will give information. It is so colorful and moving that it demands your attention. It is so simple and brief that 'he who runs, may read.' Point of view and slogan are respectively so arresting and appealing that the message lingers and leads the observer to favorable action or good will."[7] This simplicity is evident in Lester Beall's pioneering series of posters for the U. S. Government's Rural Electrification Administration (REA), produced between 1939 and 1941. At this time there were still areas of the United States such as Appalachia where there was no electricity available. The government had built major electrical generating facilities such as the Tennessee Valley Authority and determined that it was necessary to advertise the benefits of having electricity in the home. Beall's REA posters *Light*, *Wash Day*, and *Power on the Farm* clearly show the influence of the European avant-garde on his graphics: the use of silhouetted photographs, angular type and image, lines and dots as patterns, arrows, and sans serif type. Beall's REA series were noteworthy in that they were the first American posters ever to be exhibited at the Museum of Modern Art in 1937.

The New York World's Fair, held in New York City in 1939, gave a futuristic view of Utopia to many Americans. A number of outstanding posters were created to promote the fair, including works by Joseph Binder, Nembhard N. Culin, Albert Staehle and John Atherton. Binder's poster featured the symbolic Trylon and Perisphere, and captured America's coming of age before the beginning of World War II. The Fair provided creative work for many European immigrant designers, as well as progressive American architects and industrial and graphic designers who were open to the fresh insights of Modernism. Murals, maps, exhibits and printed materials were produced by Ladislav Sutnar and Will Burtin. The Fair also provided inspiration and competition for emerging young American designers such as Paul Rand and Bradbury Thompson. Together these individuals, both immigrants and enlightened Americans, forged an approach toward a Modernist style in graphic design that remains today as a basis for functional visual communication.

Europe's loss was America's gain as Hitler's totalitarianism in Europe and the beginning of World War II continued to bring major European designers and artists to the United States. Alexey Brodovitch, Egbert Jacobson, Frederick Kiesler, Ben Shahn, Cipe Pineles and Dr. Mehemed Fehmy Agha had immigrated early in the 1930s. But the majority arrived at their "foster home" on the eve of World War II. Two of the giants among poster designers, A. M. Cassandre and Jean Carlu chose to visit and then return to Europe. Will Burtin, Gyorgy Kepes, Herbert Matter, Herbert Bayer, Ladislav Sutnar, Leo Lionni, Joseph Binder, Erik Nitsche, and George Giusti arrived and spent the remainder of their careers contributing to the evolution of Modernism in American graphic design. Several masters of the Bauhaus also arrived in the safe haven of America, namely László Moholy-Nagy, Walter Gropius, Mies van der Rohe, Marcel Breuer and Josef Albers.

The plethora of posters for business and industry slowed dramatically during World War II. In their place came many outstanding propaganda posters, as those artists and designers who were not in the military put their talents behind the war effort. This genre of posters was typically evident in themes such as informing the public, wartime assignments, patriotic symbols, soldiers, indoctrination of youth, and victims of war. In 1941 Charles Coiner's design for *America's Answer! Production* poster was drawn by French poster artist Jean Carlu. Coiner, a distinguished art director at N.W. Ayer Advertising in Philadelphia continued making pro bono design contributions to the war effort. He designed a system of identification symbols for the Office of Civilian Defense whose purpose was to facilitate a defense system for the American homeland in case of attack. These symbols were shown on a 1942 information poster *Official Civilian Defense Insignia.* Carlu also designed another propaganda poster, *America Open Your Eyes*, in 1941.

The purpose of any poster is to attract the eye in the briefest of intervals.

Christopher Mount

Leo Lionni designed a powerful series of wartime posters including *Keep 'Em Rolling*, showing Navy PT boats. *Fuori I. Tedeschi* (Out with the Germans), attributed to Lionni, was produced for the Office of War Information in 1942. This strikingly graphic image combined type and a graphic hand punching Hitler. Abstract propaganda posters gave way to a more illustrative style that were more direct and less open to interpretation and confusion. The poster *This is the Enemy* by Karl Koehler and Victor Ancona was an award winner in the National War Poster Competition, sponsored by the Museum of Modern Art in 1942.

America was well aware of the impending World War. For the August, 1941 issue of *Fortune* magazine, eight artists, graphic designers and photographers were commissioned to create a series of small format posters. The editors wrote a short essay to go with the posters:

> As an instrument of propaganda and morale the poster is cheap, efficient, and pliant. These posters do not pretend a scientific derivation. They were conceived primarily to suggest the possibilities of new techniques and new uses for old techniques. Criticism may be made that some are too sophisticated for general circulation. *Fortune* feels, however, that danger lies in the direction of underestimating rather than overestimating the public taste. Moreover, it should be remembered that posters can be designed for specific audiences.[8]

8 "A Portfolio of Posters," *Fortune* 24 (August 1941): 79.

George Giusti's *Join A. R. P.*, a bold poster from this set, exemplified the interest in keeping war posters representational in style. Joseph Binder designed an outstanding poster, *Labor: Step into This Picture*. Binder, who had immigrated from Vienna, also produced a noteworthy series of posters for the U.S. Navy and for A&P Coffee in the years after World War II. Binder's style has been characterized as "functional stylization." This pragmatism was apparent when he wrote, "The history of art teaches us that art originally served a purpose. Through the connection of life with a purpose every age had its own style, which is why a style is not a technique but the consequence of knowledge and efficiency of contemporary thinking."[9]

9 Steven Heller, "Bearing the Modern Message," *Print* 42 (January/February, 1988): 97.

Women's support of the war effort was critical to America's success. "Rosie the Riveter" was the women's icon of the war years. However there were others such as the *Women Work for Victory* poster, done in 1942, which came from the WPA Connecticut Division. Printed by the silk screen process, this poster emphasized women's all-around contributions on the farm, in the office and in the factory.

The post-World War II years were ones of great economic and social growth. Americans were on the move. In 1947, the New York Subway Association sponsored a series of posters. E. McKnight Kauffer's *A Subway Poster Pulls* and Erik Nitsche's *Say It Fast… Often… in Color* were from this series. Kauffer also designed travel posters for American Airlines to entice travelers to visit New York. Oscar M. Bryn's travel posters promoted cross-country travel by rail on the Santa Fe.

10 Wrede, 34.

In contrast, "The end of the war brought other serious issues to the fore, among them voter registration and civil rights, polio, and nuclear annihilation."[10] Posters were used to counter this serious fear of nuclear proliferation. Nitsche's *Exploring the Universe* for General Dynamics emphasized the theme of the peaceful benefits of atomic energy. Exemplifying the national concern for security in the midst of the Cold War years was the powerful *Stop H Bomb Tests* by the artist Ben Shahn. One of the outstanding women poster designers from 1955 was Jacqueline Casey. In her 30 years as a designer at the Massachusetts Institute of Technology, she produced a body of poster work that was strongly influenced by Swiss design and yet rich in formal visual values, to promote MIT programs.

11 Jon Borgzinner,
 "The Great Poster Wave,"
 Life 63
 (September 1, 1967): 36.

The 1960s were a time of great cultural, political and social change in America. *Life* magazine reported in 1967, "Suddenly posters are the national hang-up. They serve as low-cost paintings, do-it-yourself wallpaper, comic Valentines or propaganda for such things as Batman and rye bread … More than a million a week are gobbled up by avid maniacs who apparently abhor a void."[11] Design and author Steven Heller has written, "In America, the poster finally came of age during the late 1960s."[12] Noteworthy among the great posters of the 1960s were Milton Glaser's *Dylan*, Paul Davis's theatre posters, James McMullan's posters for Lincoln Center, and Ivan Chermayeff's posters to promote music and dance companies. Chermayeff, a principal in Chermayeff and Geismar in New York, is also known for an outstanding series of posters created to promote and advertise dramatic productions on Public Television for Mobil.

12 Steven Heller, ed.,
 *The 100 Best Posters
 from Europe and the
 United States, 1945–1990*
 (Tokyo: Toppan Printing
 Company, 1995), 23.

We live in modern times of life and mind. Everything moves faster today. In poster design we need the same speed to put the message across effectively. Communication must be dramatic.

Joseph Binder

In California, designer Saul Bass emerged on the national scene in 1955 with a completely new style of film titles and posters. His posters for *Man with the Golden Arm* and *Anatomy of a Murder* were but the beginning of a long series of dramatic graphic promotions in which he expressed central themes from the films in powerful, symbolic form.

The high point of politics in America in the 1960s was the election of John F. Kennedy, and the Camelot years which followed. Ubiquitous *Kennedy for President* posters promised "Leadership for the 60s." Otherwise, the most important poster event in America in the 1960s was the appearance of psychedelic and rock posters from California. "Electric colors" and completely unreadable typography provided an unmistakable "universal graphic language" for the era of sex, drugs, and rock and roll. Many of these posters reflected an eclectic style which brought back elements of the Victorian, Vienna Secession, Jugendstil, Indian and Native American styles, with "day-glo" color and typography reminiscent of comic books. These posters were created to promote bands and alienate everyone else. This was the beginning of what would become, in retrospect, "the art of modern rock."

13 Paula Scher,
e-mail message to author,
May 2, 2006.

14 Carol Wells,
*Newsletter of the
Center for the Study of
Political Graphics,
Poligraphics*
Winter, 2005.

Artists and designers such as Rick Griffin, Alton Kelley, Victor Moscoso, Stanley Mouse and Wes Wilson produced many of these day-glo wonders. Moscoso's *Hawaii Pop Rock Festival* poster combined a surreal montage of images with rows of heavy-serifed, barely legible type. This style was fashionable and influential for a while but became outdated and new trends started to emerge, especially from the East Coast with work by Milton Glaser, Tomi Ungerer and Seymour Chwast. Consistent with the "in your face" attitudes of the 60s, Tomi Ungerer's style, for instance in his 1967 posters *Eat* and *Black Power White Power*, was simple yet powerful. These posters were excellent examples of an illustrator making images that brought social issues to the forefront. Glaser's poster for singer Bob Dylan, created for CBS Records, heralded the fact that in 1966 the times were indeed "a-changin.'" For many the *Dylan* poster became the iconic form of the 1960s. Photographer Richard Avedon created a series of four experimental Beatle portraits for a January 9, 1968 article in *Look* magazine titled *Sound and Fury in the Arts*. Each image, such as the *John Lennon* poster, exemplified a different type of psychedelic image form. The portraits in *Look* were originally "a pullout portfolio of the Beatles," and later were made available as a large-format poster set.

These artists and designers challenged the functional values of Modernism with post-Modernism, and were nostalgic for Victorianism, Art Nouveau and Art Deco styles. Using this eclectic approach, the American designer Paula Scher contributed important posters to our visual environment in the late 1970s. A partner at *Pentagram* in New York, she had previously created provocative posters for CBS Records. Her *Best of Jazz* poster used wood types and was composed in the manner of 1920s Russian Constructivist design. Her charge was to "Get twenty names on it. Make them really big. Do it fast and cheap."13

On the flip side of the psychedelic era was a serious concern for social issues and especially the opposition to the war in Vietnam. Historically, political posters have served the purpose of inspiring us to action. Many posters were created to express disdain for the Vietnam War. A *Talk is Cheap* poster, designed in 1968 by the Student Mobilization Committee to End the War in S. E. Asia said, "Talk is cheap. The war is not over until all the GI's are brought home alive." Another iconic anti-war poster was the 1969 *War is Good Business*, with a photograph of Michelangelo's *Pieta* and the subtitle "Invest Your Son." The 1970 Q. *And Babies?* A. *And Babies* poster also used photographic imagery. Transparent blood-red type was superimposed on a color photograph of dead Vietnamese families along a dirt road. Carol Wells, Director of the Center for the Study of Political Graphics wrote, "Political posters are weapons against despondency and disillusionment because they show us that we are part of the continuing struggle against war and injustice—a history that is neither taught in school nor presented by the media."14

Political posters are always designed for a specific audience, and there must be a very clear relationship between the poster and its audience. The *Cleaver for President* poster from 1968 was sponsored by the Black Panther Party and the Peace and Freedom Party. It promised "power to the people" and "black power to black people." Ron Borowski's *I Pledge Allegiance* poster from 1970 reminded Americans of the racial injustice still in America. The superimposition of the American flag on the black man's face was a powerful symbol of racial ambiguity. The styles of political posters may vary considerably, from those promoting peace to those announcing a demonstration, and there can also be great contrasts between posters designed by graphic designers or artists or those designed by passionate citizen advocates. But as Carol Wells said, "In the best, the passion, message and aesthetics coincide."[15]

15 Wells.

If a thousand years hence, our decendents search among the ruins of our civilization, they might learn more of our way of life from excavated posters than paintings. The poster reflects the cultural, social, economical and technical age we live in, forcibly and directly. It touches on ideas and ideals, customs, taboos, what we eat, make, use, buy and sell individually and collectively.

Abram Games

Other public issues also became prominent in the 1970s, namely the environment, the Native American movement, and nuclear war. Artist Robert Rauschenberg designed the first Earth Day poster in 1970, which featured a dominant American eagle surrounded by photographs. Reminiscent of John Heartfield's photo-collages of the 1930s, this poster presented a panorama of reminders of how society was polluting the natural environment. The plight of Native Americans was documented in the *Wounded Knee* poster which claimed that "the spirit of the past will rise to claim the future." While there was hope for a peaceful application of atomic energy, by 1974 there were many who questioned the dangers implicit in using nuclear weapons for defense. Lisa Emmons's poster *And Then There Was Nothing* gave viewers little hope for the future after a nuclear war, as she promised us "nothing."

The "Age of Aquarius" gave way in the 1970s to a "new wave," also from California. This "wave" manifested itself in several ways. Former actor and California Governor Ronald Reagan was elected President. Although some Americans were happy with this new conservatism in the land, others were not. Eventually in 1985, Jay Johnson's poster *The Real Face of Terror*, reminded us of Reagan's many misadventures in the world such as in Nicaragua, Grenada, etc. Many Americans were concerned with the ongoing problem of drug addiction. Robbie Conal's poster *Contra Cocaine* showed a frightening skull surrounded with a military camouflage pattern, suggesting the illicit relationship between the military in Nicaragua and drug trafficking. American Presidents have always been good subjects for political posters. Even as recently as 2004, a poster by Mear One, *Let's Play Armageddon,* showed a caricature of President George W. Bush making a paper airplane of the Bill of Rights, with a nuclear cloud in the background.

Women's rights were also very much in the public consciousness. This was especially evident in the "Guerrilla Girls" organization and their activities. Their poster *The Birth of Feminism* from 2001 promoted the hypothetical film of the same name and called for "Equality now." The photograph of the three women on the poster "made women's rights look good. Really good."[16] The poster was published by the Center for the Study of Political Graphics in Los Angeles.

16 Wells.

Before the millennium and in contrast to the activism and political posters of the time, there were other more placid and pictorial expressions. They created a kind of West Coast retro style. Michael Schwab from California designed a series of poster images for the Golden Gate National Parks. These simple image harkened back to the 1930s and the tourism graphics of Otis Shepard and William P. Welsh.

> The poster is like a telegrapher– he does not direct messages, he dispatches them.
>
> A.M. Cassandre

The other form of "new wave" of the 1980s was more graphic and literal. A post-Modern style was emerging in reaction to many years of the seemingly simpler Modernist period. This style was reminiscent of Surrealism, and with the availability of the computer and sophisticated digital graphics tools, a new type of poster designer emerged. In California April Greiman experimented with digital tools to create innovative posters, including a fold-out self portrait for *Design Quarterly* journal, *Does It Make Sense?* for The MIT Press, and the theme graphic for *The Modern Poster* exhibit at New York's Museum of Modern Art in 1988. Commenting about the form of the digital era, her colleague Eric Martin wrote:

> The computer collapses all conventional media into a common digital language of patterns of on/off electrical impulses. The boundaries between previously separate formats and skills begin to blur. Greiman has coined the term "hybrid imagery" to describe this mingling of digital image/text/page composition technology with traditional photomechanical techniques for print production... Digital technology is entering a period in which it is not only reinventing print technology but it is creating wholly new formats which combine sound, motion, and interactivity. These new digital hybrids will become the platform for the designers of tomorrow."[17]

17 April Greiman, *Hybrid Imagery: The Fusion of Technology and Graphic Design* (New York: Watson-Guptill Publications, Inc., 1990), 13.

The Poster Today

During its century-long development, the poster has remained a remarkably resilient media form. Steven Heller has written, "There is now a realization that graphic design is not as ephemeral as the paper it is printed on. Certain advertisements, posters, packages, logos, books, and magazines endure as signposts of artistic, commercial, and technological achievement and speak more about particular epochs or milieus than fine art."[18] Even though in the United States the poster is not a principal vehicle for commercial advertising, it remains important in documenting our rich history.

18 Steven Heller, *Design Literacy: Understanding Graphic Design,* 2nd ed. (New York: Allworth Press, 2004), XI.

Posters appear occasionally in public spaces such as railroad and subway stations, along the highways as billboards, and in movie theatres. Of special importance is its use as a mass-produced popular cultural medium. Nowadays we even have "gig posters," which reflect the power of rock music in our culture. These posters "embrace a wide range of raucous comic styles and typographies–as well as frequent parodying of, and homages to, passé fashions (including psychedelics)–intended to convey moods and make statements that are often satirically political."[19] A look at recent posters produced by the American Institute of Graphic Arts is not a hopeful one. With the best post-Modern sensibility, imagery and text are combined by a layering process for textural effect, rather than for communicating a message. This "new complexity," as Steven Heller calls it, "has not produced extraordinary poster design." The ideals of practicality and Modernism seem to be on hold somewhere as personal expression holds sway.

It is easy to become enthralled solely with the aesthetic aspects of the poster, and neglect its semantics, message and communicative power. Today posters are being shown in a California venue, *The Anti-War Show*, sponsored by the Center for the Study of Political Graphics. This exhibit "contains beautiful, humorous, ironic and stunning posters. But to avoid creating an overly aestheticized exhibition that could visually seduce viewers away from the horrors of war while simultaneously protesting war, there are also posters that show the dead and dying. These not only remind viewers that wars kill civilians and cause people to die horribly, but also that ordinary people can commit crimes against humanity, such as shown in posters about the My Lai Massacre, or torture in Abu Ghraib prison."[20] Posters from Iraq are being shown in American newspapers as a way of giving the embattled citizens of that country information about the candidates for their first democratic election.

The Swiss designer and teacher Armin Hofmann noted, "The poster has a chance of survival only if it recollects its most innate strength: size, clarity and simplicity ... Practically speaking, the designer of tomorrow will have to pursue research in the area of the sign. [This is a reference to the 'sign' in terms of its generic meaning as used in semiotic theory.] He will not be able to simply let the machine transfer a design onto the printing carrier."[21] Paul Rand posed the question, "The poster, is it to persuade, to sell, to inform or to amuse? The response to such questions implies experience, not only with history, design and marketing but with the psychology of salesmanship, the philosophy of aesthetics and the drama of communication. Brevity and wit play a role as do talent, good fortune, a receptive and intelligent client and an audience conditioned to accept good work."[22]

19 Steven Heller, "Smashing Posters." Review of *Art of Modern Rock: The Poster Explosion*, by Paul Grushkin and Dennis King, *The New York Times Sunday Book Review* (December 5, 2004): 53.

The poster can be a concise summary of say, a half-hour's speech
Abram Games

20 Wells.

21 Dawn Ades, *The 20th-Century Poster: Design of the Avante-Garde* with contributions by Robert Brown, et al. (New York: Abbeville Press, 1984), 93.

22 Heller, ed., 8.

23 Wrede, 11.

24 Wrede, 39.

In 1912 the poet Guillaume Apollinaire wrote that catalogs, posters, advertisements of all sorts…"Believe me, they contain the poetry of our epoch."[23] Just like graphic design itself, the poster has always been a hybrid medium. It exists at the juncture of the arts, design and business as well as that place where painting, drawing, photography and typography come together in new ways. "Involved in everyday cultural, political, or commercial issues, the poster at its best has been, and continues to be, an extraordinary social and artistic document."[24] It may be that from these blended roots, both the art poster and the information poster will again spring forth to achieve their full poetic potential.

A NOTE ABOUT THE POSTERS

Each poster displayed in the following section is assigned a reference number. Dimensions given are of the poster sheet itself; the dimensions of the image on the sheet may be smaller. The printing process is also identified. If a combination of printing methods was used, the dominant method is noted. When no specific method is dominant, every readily-discernable printing process is listed. The principal printing processes used to produce posters are:

Relief Printing

An image is cut or carved in relief onto the face of a hard material, usually a woodblock. Ink is then applied to the raised image on the block and brought into direct contact with a sheet of paper, yielding a print. A different block is used to print each color in a multicolor poster.

Lithography

An image is drawn onto a flat plate with an oil-based crayon or ink. Water is then applied to the plate, followed by the application of an oil-based ink. The ink adheres to the greasy drawing but is repelled by the water-saturated, non-image areas. A sheet of paper is brought into direct contact with the plate (or, in offset lithography, the image is transferred or "offset" from the plate onto a special rubber blanket cylinder which is then brought into direct contact with the sheet of paper). Lithographic plates are typically made of stone or metal, and a different plate is used to print each color.

Photolithography

An original continuous-tone drawing, painting, or photographic image is photographed through a halftone screen, breaking the image into a pattern of minute dots which, through a series of steps, is affixed to a lithographic plate and printed as described in the previous Lithography section. If the image is to be printed in color, the original must be photographed through a series of red, green, and blue filters to separate the image into its component primary colors. Each of the resulting halftone color components is affixed to a separate plate and printed one after the other, in register, with inks standardized to the "process" colors of cyan, magenta, and yellow. A fourth, black-printing plate is almost always added to provide shadow detail and accurate grays.

Screen Printing

An image is broken into stencil-like shapes and applied to a finely woven screen stretched on a frame. Non-image areas are blocked by a mask or frisket. Ink is pushed with a squeegee across the screen and through the stencil onto a sheet of paper placed immediately below. As many additional colors as necessary can be added to the resulting print by repeating the process with a new stencil, and sometimes new screens. In the early days of the process, the screen was usually made of silk or organdy.

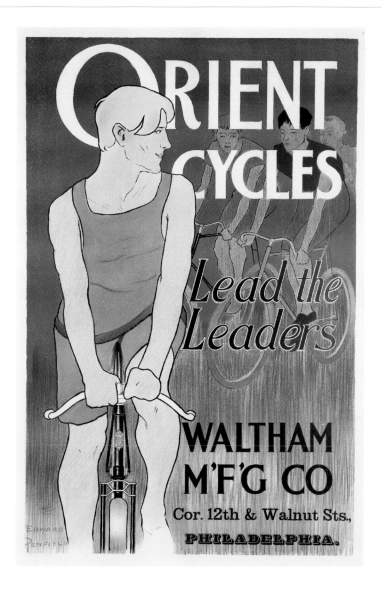

1

Edward Penfield
1866–1925

Orient Cycles
ca. 1895
42⅛ × 28⅜ inches
Lithography

PUBLISHER
Waltham
Manufacturing Co.

PRINTER
J. Ottmann Lith. Co.
New York, NY

Penfield, often referred to as the "father of the modern American poster," designed several bicycle posters in the 1890s. Cycling was the rage and had a significant social impact, especially on women. It helped to free them from the home and even changed their manner of dress. This poster's integration of word and image distinguishes it from pre-Penfield advertisements: the middleground text graphically separates the lead cyclist, who uses the touted product, from those who lag behind. The stamp on the bottom left margin is that of the famous French art dealer Edmond Sagot, reflecting Penfield's early international appeal and influence.

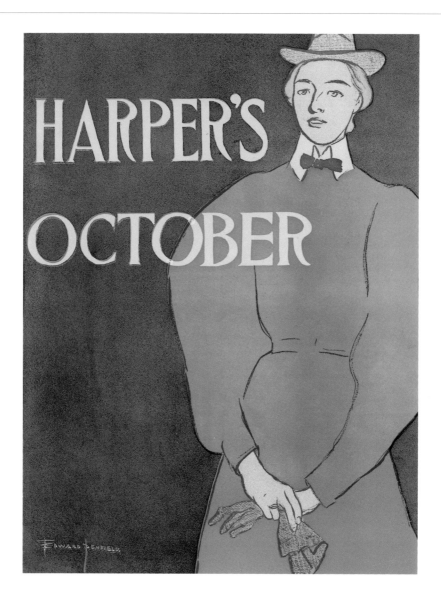

2

Edward Penfield
1866–1925

Harper's October
1896
18¼ × 13¾ inches
Lithography

PUBLISHER
Harper & Brothers
New York, NY

PRINTER
Unknown

It was a new idea to publish a different poster advertising each issue of a magazine–an idea Penfield brilliantly executed at *Harper's* for most of the 1890s. (Such "literary" posters were small, as they were to be used in book stores jammed with advertisements.) Here, Penfield shows the consumer but not the product, pioneering the modern approach of selling "image." Sophisticated, at leisure, and aloof from everyday concerns, this woman is the quintessential *Harper's* reader! Penfield's style is also new. Even critics presuming French and Japanese influences–in his solitary figures, simplification of forms, and flat planes of color–conceded Penfield's overall originality. Penfield himself acknowledged only the figures on Egyptian sarcophagi as inspiration.

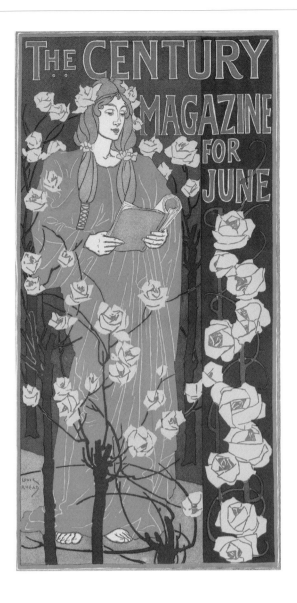

3

Louis J. Rhead
1857–1926

The Century Magazine for June
1896
21⅛ × 10⅞ inches
Lithography

PUBLISHER
The Century Co.
New York, NY

PRINTER
G. H. Buek & Co.
New York, NY

Having studied art in his native England and in France, Rhead settled in the United States in the 1880s. The influence of classicism, the pre-Raphaelites, and Art Nouveau's curvilinear ornamentation is evident here. So are John Ruskin's and William Morris's Arts and Crafts tenets. Echoing their views, Rhead believed that posters, comprising the "poor man's art gallery," have a "moral aspect" and can elevate or compromise the people's ethics. In this poster, the classically-attired woman appears chaste and contemplative, strolling through a garden alive with Art Nouveau flourishes that unify the composition's distinct planes. The poster's verticality only reinforces her "uprightness."

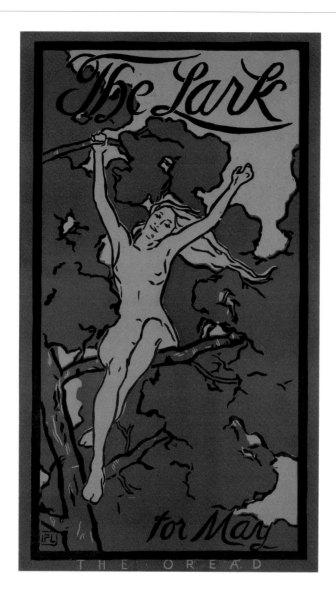

4

Florence Lundborg
1871–1949

The Lark for May
1896
23⅞ × 13¹⁵⁄₁₆ inches
Relief Printing

PUBLISHER
William Doxey
San Francisco, CA

PRINTER
Unknown

The 1890s craze for mass-market publications, and the posters advertising them, was driven by several post-Industrial Revolution factors: the emergence of a literate middle class with leisure time; improved, lower-cost printing technology; urban expansion; and a desire for "culture" and "aesthetic" products. Lundborg was one of several accomplished female American poster designers (Europe had none). A highly-trained painter, she designed posters and illustrations for the _Lark_, one of the more intellectual and irreverent "little" monthly magazines. Lundborg's Arts and Crafts-influenced woodblock posters often depicted nature and were printed on exotic Asian papers. The _Lark_'s bohemian attitude is aptly expressed in this wood nymph's unselfconscious cavorting.

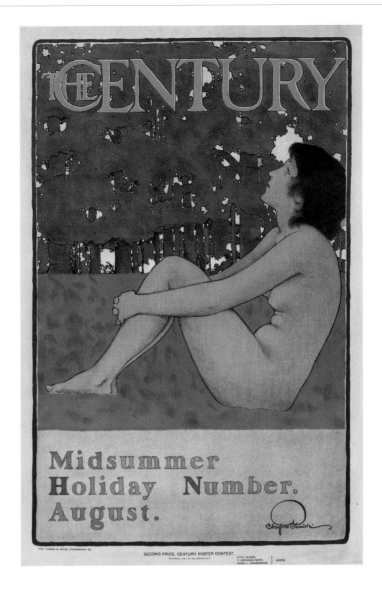

5

Maxfield Parrish
1870–1966

The Century
1897
19¾ × 13 inches
Lithography

PUBLISHER
The Century Company
New York, NY

PRINTER
Thomas & Wylie
Lithographic Co.
New York, NY

Parrish's career as a painter, illustrator, and designer included works epitomizing the 1890s "artistic" poster, i.e., posters designed by independent, formally-trained artists who signed their work. (Previously, posters were the domain of skilled craftsmen employed by printing firms.) With the growth of advertising, and the popularity of posters eclipsing that of the associated literature, competitions were held to attract top artists. Here, the *Century* awarded Parrish second prize–not first because he exceeded the contest's three-color limit! This late Art Nouveau poster (more painterly, less ornamental) features Parrish's "trademark" androgynous nude, gazing at the magazine's title, and a lush, imaginary landscape … suggesting the fantastical places to which the *Century* readers are transported.

6

Joseph B. Hallworth
1872–1957 ?

Kar-Mi Swallows a Loaded Gun Barrel
1914
28⅛ × 41⁹⁄₁₆ inches
Lithography

PUBLISHER
Joseph B. Hallworth

PRINTER
National Printing & Engraving Company
New York, Chicago, St. Louis

American printing firms were the first to publish large-format, color lithographic posters. From the 1870s to 1930s, they were the leaders in "show paper," as circus, magic, vaudeville, theatrical, and concert posters were called. An anomaly, this show poster was designed by the magician himself. "Kar-Mi" was actually the American Joseph Hallworth, one of several magicians who posed as a mysterious, turbaned man from the East, and whose posters highlighted those supposed origins. Magic posters portrayed the magician or, as here, one of his tricks. This poster's horizontal design emphasizes the difficulty of the feat, which was also suspected of causing Hallworth's death from stomach cancer.

7

Clarence Coles Phillips
1880–1927

Light Consumes Coal
1917
27⅞ × 20⁷⁄₁₆ inches
Lithography

PUBLISHER
United States
Fuel Administration
Washington, DC

PRINTER
Edwards & Deutsch Litho. Co.
Chicago, IL

*George Creel in Gary Borkan,
World War I Posters
(Atglen, PA: Schiffer, 2002), 5.

In 1917, the United States entered World War I and poster designers turned their attention to propaganda. The Committee of Public Information, with the Society of Illustrators, formed the Division of Pictorial Publicity (DPP). This public-private sector alliance undertook "a vast enterprise in salesmanship, the world's greatest adventure in advertising."* Given the Society's role–and that 1890s Art Nouveau and "artistic" posters were distant memories– the dominant style of these posters was illustrational. Yet this poster masterfully combines Nouveau, modern, and illustrational elements. Although the attractive image barely evokes the war, the conservation message nonetheless comes through.

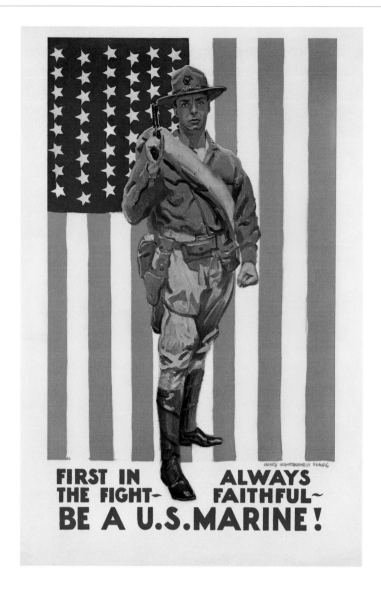

8

James Montgomery Flagg
1877–1960

Be a U.S. Marine
1918
42¼ × 28 inches
Photolithography

PUBLISHER
U.S. Marine Corps
Department of
Pictorial Publicity
Washington, DC

PRINTER
Unknown

This was the golden age of commercial illustration. The most famous illustrators, media giants before the advent of radio and television, were among the highest-paid Americans; yet they volunteered for the DPP. An ardent advocate of the war, Flagg sought to rally the long-neutral and xenophobic U.S. This recruiting poster is less famous than his "I Want You" poster but equally strong, aggressively selling soldierdom. What young man could resist the cool, tough marine's patriotic "direct order"? Nor is it surprising that the dramatic opening of the 1970 film *Patton* appropriates this image, with a huge, iconic flag serving as the charismatic general's backdrop.

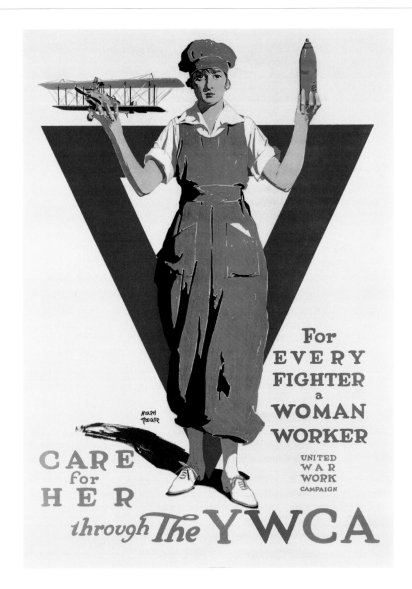

9

Adolph Treidler
1886–1981

For Every Fighter a Woman Worker
1918
40⅜ × 29 inches
Lithography

PUBLISHER
Young Women's
Christian Association

PRINTER
American Lithographic Co.
New York, NY

* Walton Rawls, *Wake Up America!*
World War I and the American Poster
(New York: Abbeville, 1988), 167.

In only twenty months, the DPP arranged for roughly 700 poster designs by 300 artists for 60 government departments.* Some art historians have criticized these posters as overly pictorial. (Like other Americans, most illustrators were suspicious of foreign ideas and did not adopt European avant-garde practices.) But they were effective propaganda, capitalizing on realistic detail, narrative, and evocativeness. Here, each of Treidler's devices underscores the importance of women, and the YWCA, in the home front war effort: the highlighted "w" in YWCA; the stance of the model (Treidler's wife), which echoes the organization's blue triangle logo; and the model's heroic proportions.

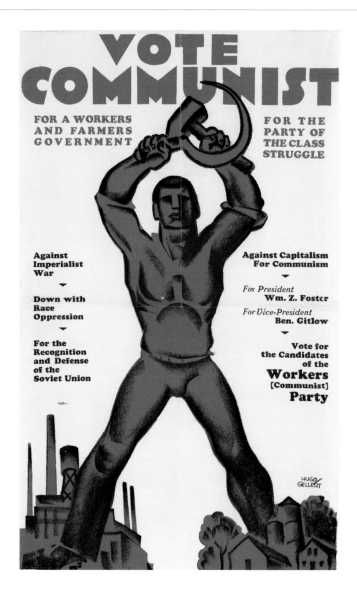

10

Hugo Gellert
1892–1985

Vote Communist
1924
22 × 13½ inches
Lithography

PUBLISHER
Workers Party

PRINTER
Allied Printing
New York, NY

A 1919 spinoff of the Socialist Party, the Communist Party of the U.S.A. (CP) struggled in the 1920s due to its extremism, in-fighting, and government suppression. Eventually the CP unified and reached out to other leftist groups, gaining members and sympathizers during the Depression (a disaster which, the CP said, proved capitalism's failure). Gellert, a Hungarian émigré, was a communist, union organizer, and activist. For him, art and politics were indivisible. In this poster supporting CP member William Foster's bid for the U.S. presidency, Gellert demonstrates his assimilation of the Stalin-decreed Socialist Realist style.

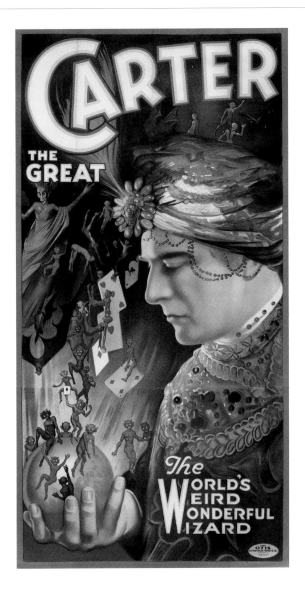

11

Designer Unknown

Carter the Great
1926
77⅝ × 41⅛ inches
Lithography

PUBLISHER
Charles Carter

PRINTER
Otis Litho Co.
Cleveland, OH

A quintessential "show" poster: collaboratively designed and beautifully printed by a leading printing firm's highly-skilled craftsmen, who were likely immigrants rigorously trained in art academies in their native Germany. The team approach meant no individual signed a poster– or became too empowered within the firm. The immigrants' strong background in drawing and lithography (invented in Germany in 1796) ensured realism and technical mastery. Carter, a savvy businessman-lawyer as well as great conjurer, began his magic career at 10, became rich making world tours, and died in India at 62, a few months after being crushed by an elephant. This portrait poster advertises Carter and his "magicality," not a particular trick.

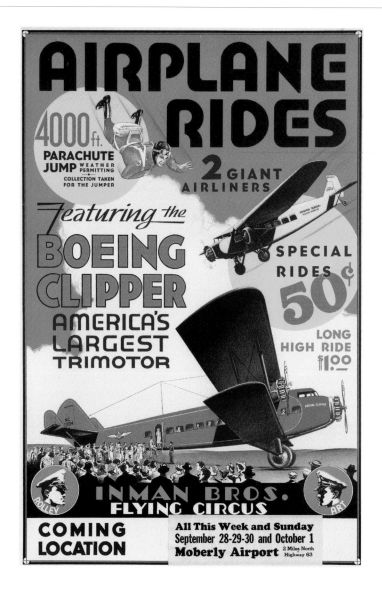

12

Designer Unknown

Airplane Rides
ca. 1929
37^{15}/$_{16}$ × 25 inches
Lithography

PUBLISHER
Inman Bros.
Flying Circus

PRINTER
Unknown

This is another poster in the "show" tradition, with roundel portraits of the showmen, bright colors, and an abundance of illustration and text. It is less polished than the preceding example, reflecting a straightforward, business-like pragmatism that is distinctly American. But even with its emphasis on information over aesthetics, it is good-looking and has considerable vernacular appeal. The Inman Brothers' flying circus, performing in the 1920s and 1930s, included the biggest aircraft ever used in such events. An affordable entertainment, the circus gave hundreds of thousands their first opportunity to fly.

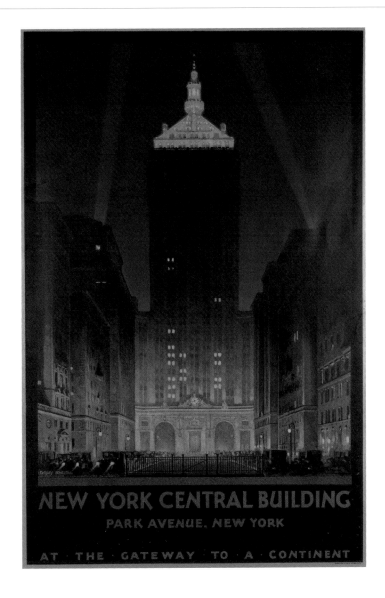

13

Chesley Bonestell
1888–1986

New York Central Building
1930
40¹⁵/₁₆ × 26¹⁵/₁₆ inches
Lithography

PUBLISHER
New York Central Lines
New York, NY

PRINTER
Latham Litho & Ptg Co.
Long Island City, NY

Although the 1920s were the heyday of the passenger railroad, the Depression and automobile would rapidly take a toll, and air travel would deliver the final blow. "At the gateway to a continent," the New York Central Building (now the Helmsley Building) was designed by Warren and Wetmore as a major element in the Grand Central Station complex. Printed on heavy stock using metallic ink, this is the extravagant centerpiece of a high-profile, multi-poster campaign by NYCL. Bonestell, one of the nation's foremost architectural illustrators, uses architectural detail to perfectly capture the glamour and prestige of luxury railroad travel, without a locomotive or destination in sight.

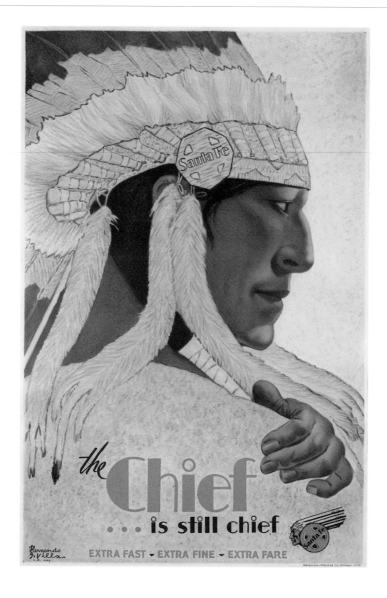

14

Hernando G. Villa
1881–1952

The Chief... is Still Chief
1931
41½ × 28 inches
Lithography

PUBLISHER
Atchison, Topeka, and
Sante Fe Railroad
Chicago, IL

PRINTER
Newman-Monroe Co.
Chicago, IL

* Michael E. Zega and John E. Gruber,
Travel by Train; The American Railroad Poster,
1870–1950 (Bloomingdale, IN: Indiana
University Press), 24, 77.

The Chief line was deluxe and high-speed, responding to pressure to reduce travel time between Chicago and California. The line started in the "Roaring Twenties," but even during the Depression its desirability and exclusivity allowed it to tout "extra fare" as a virtue! The dignity of the iconic chief in his prime contrasted sharply with contemporary stereotypical depictions–unsurprising, as Villa admired Native Americans and spent months with a tribe "before drawing a line." Santa Fe's posters led the industry and, as here, used symbols "to effectively communicate the line's southwest routing" and prestige.*

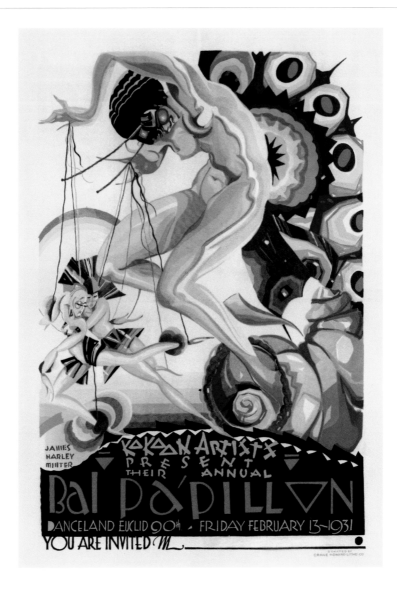

15

James Harley Minter
dates unknown

Bal Papillon
1931
19¾ × 14 inches
Photolithography

PUBLISHER
Kokoon Arts Club
Cleveland, OH

PRINTER
Crane Howard Litho. Co.
Cleveland, OH

* *Kokoon Arts Club, Papers, 1922–1935* (Kent, OH:
Kent State University Libraries, 2005), http://
speccoll.library.kent.edu/other/kokoon.html.

The conventional view is that the 1913 Armory
Show marked modern art's arrival in America.
But in 1911 a group of talented bohemian
artists, already immersed in European movements,
formed the Kokoon Artists Club (one of several
such U.S. clubs). The founders, all young men,
held "day jobs" at Cleveland commercial
lithography firms. They named the club for
"the lowly cocoon … forerunner of the beautiful
butterfly [in] hope that from this small beginning
something of beauty [will] emerge."* The club
held well-attended, subversive, and risqué
annual fundraising balls, akin to Dada events,
with member-designed invitations-cum-posters.
For this "Bal Papillon," Minter, in a rather
psychedelic style, honors the club's origins
and spirit.

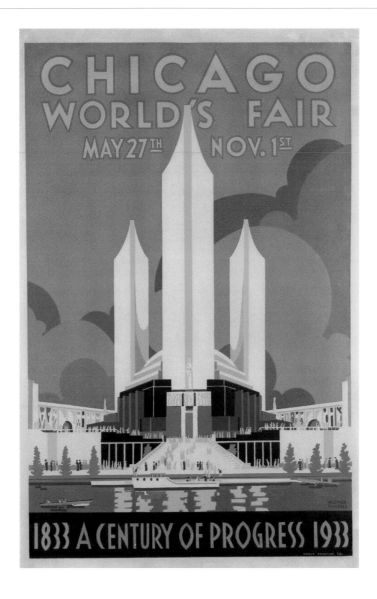

16

Weimer Pursell
dates unknown

Chicago World's Fair
1933
41½ × 27⅜ inches
Lithography

PUBLISHER
A Century of Progress
Illinois

PRINTER
Neely Printing Co.
Chicago, IL

The largest world's fairs were held in Depression-era America. Escapist, they featured technological advances Americans hoped would jump-start better times. The Chicago World's Fair, marking the city's centennial, was held at the Depression's lowest point yet was profitable. This poster's subject and style are quintessentially Art Deco–a new, progressive mode (showcased at the 1925 Exposition Internationale in Paris) appropriate to the fair's theme. Deco popularized functionalist and modern "machine age" art movements as well as decorative, exotic traditions. This poster's Deco elements include utopian, streamlined architecture; hot colors mimicking the fair's world-premiere display of neon; stylized typography; and bulbous clouds, which are the only asymmetrical feature of the image.

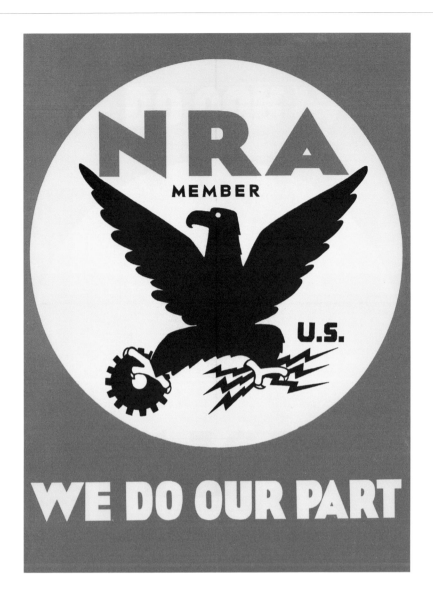

17

Charles T. Coiner
1898–1989

NRA
We Do Our Part
1934
27¾ × 20¾ inches
Lithography

PUBLISHER
National Recovery
Administration
Washington, DC

PRINTER
Unknown

* See R. Roger Remington and Barbara J. Hodik,
Nine Pioneers in American Graphic Design
(Cambridge, MA: MIT Press, 1989), 54–69.

Coiner spent his career largely at N. W. Ayer,
the venerable yet progressive advertising agency.
His art direction and executive skills greatly raised
the business standing of the "advertising man."
He hired top commercial and fine artists world-
wide for his innovative campaigns, exposing
America's corporations and citizens to modern
art. He also led his peers in volunteering for the
federal government, here designing the National
Recovery Administration's ubiquitous "Blue
Eagle."* An early New Deal cornerstone, the NRA
sought to reverse unemployment, labor's
degradation, and industry's freefall–through
employer agreements regarding production, price,
and wage-hour controls. The NRA had limited
success, but spurred labor to subsequent gains.

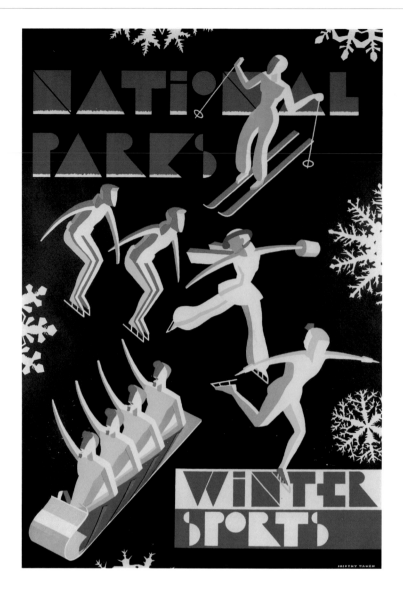

18

Dorothy Waugh
1896–1996

National Parks Winter Sports
ca. 1934
40 × 27⅝ inches
Lithography

PUBLISHER
National Parks
Service
Washington, DC

PRINTER
Unknown

Educated at the Chicago Art Institute, Waugh
lived to 100 and had a remarkable career—
as a graphic designer, illustrator, children's book
editor at Knopf, teacher at The Cooper Union
and Parsons School of Design, and published
expert on Emily Dickinson. Her juggernaut
"poster phase" consisted of at least 16 national
and state parks posters designed around 1934,
"National Parks Year." They show Waugh's stylistic
range, design clarity, and inventive typography.
Here, Waugh's Deco montage, busy yet
uncluttered, plays with scale and cropping and
uses a black background to suggest snow (!)...
all while snowdrifts accumulate at the base of
individual letters.

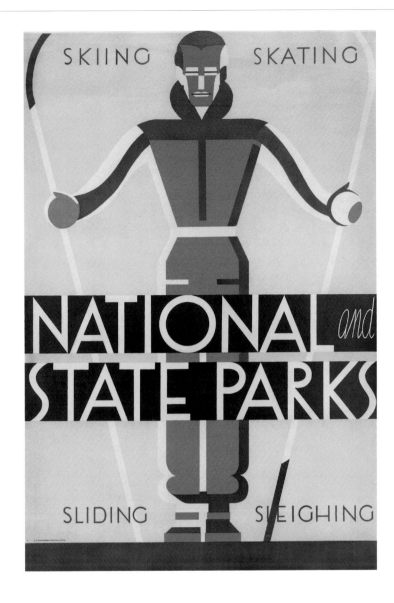

19

Dorothy Waugh
1896–1996

National and State Parks
ca. 1934
39¾ × 27⅜ inches
Lithography

PUBLISHER
National Parks
Service
Washington, DC

PRINTER
U.S. Government Printing Office
Washington, DC

Waugh's father was a horticulture professor influential in the movement to make national parklands accessible to the public. One of his pupils, highly-placed in the National Parks Service, was astute enough to hire Dorothy to create these posters (there had been almost no prominent female poster designers since the 1890s). Amidst the Depression, the National Parks Service posters aimed to remind Americans of the glory of their lands and that the country remained a place of opportunity. This poster, with its Constructivist imagery and straightforward sans serif typography, again demonstrates Waugh's range.

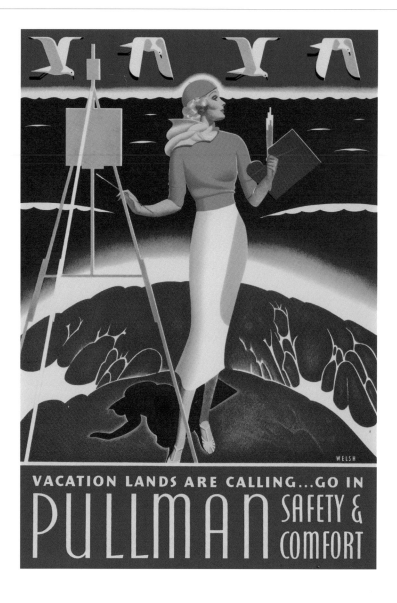

20

William P. Welsh
1889–?

Pullman Safety & Comfort
1936
27⁹⁄₁₆ × 21 inches
Photolithography

PUBLISHER
Pullman Company
Chicago, IL

PRINTER
Unknown

* Zega and Gruber, 103, 105.

The Depression and automobile had devastated the railroads, finally triggering a counterattack featuring increased efficiency and sleek advertising.* Pullman's major campaign included a dozen posters by Welsh, all Deco exemplars. "Streamlining" was rampant, but Pullman had done little to restyle its fleet of boxy cars. Welsh therefore depicted alluring destinations and the female patrons who typically arranged the family vacation (taken, if at all during the Depression, within the U.S. and often by train). Courtesy of Pullman, this beautiful, stylish customer is literally "on top of the world," while the text promotes specific Pullman attributes of luxury, comfort, and safety.

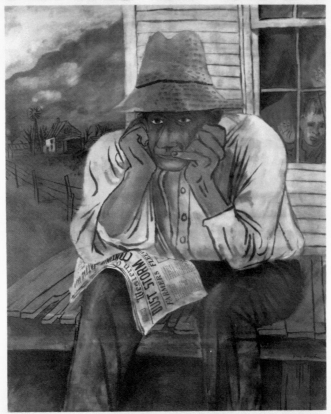

21

Ben Shahn
1898–1969

Years of Dust
1936
38⅛ × 24¾ inches
Photolithography

PUBLISHER
Resettlement
Administration
Washington, DC

PRINTER
U.S. Government Printing Office
Washington, DC

During the 1930s, the "dust bowl states" were devastated by dust storms caused by erosion– itself a product of the country's economic failure. The Resettlement Administration scrambled to relocate the destitute, often to RA-built "greenbelt" towns. As an RA photographer, Shahn traveled the country, documenting the Depression's impact. This poster, and his painting "Dust," were based on some of those photos. In its tough Social Realist style–all is wasted and begrimed by dust– the poster conveys the real depression behind the newspaper's detached headline. Throughout his career, Shahn, a Lithuanian émigré, used his extensive commercial and fine art background to do socially-engaged work.

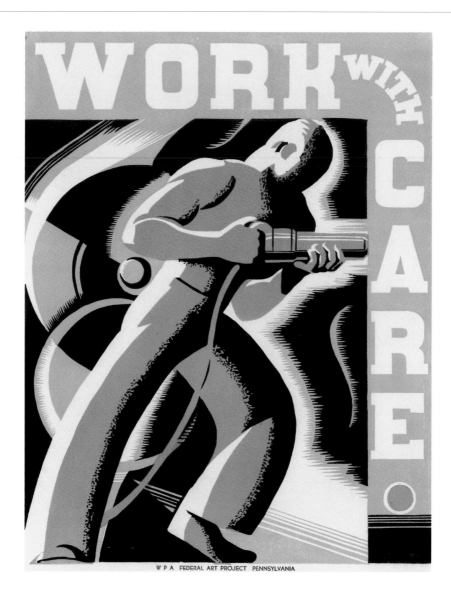

WPA FEDERAL ART PROJECT PENNSYLVANIA

22

Robert Muchley
dates unknown

Work with Care
1937
24⅞ × 18⅝ inches
Relief printing

PUBLISHER
WPA Federal Art Project
Pennsylvania

PRINTER
Graphic Arts Workshop
Philadelphia, PA

*Elizabeth Sacartoff, "WPA's First-Class Posters
Make First-Class Salesmen," PM *Weekly*
(August 17, 1941).

From 1935–1943, artists employed by the
Federal Art Project of the Works Progress
Administration created "poster art more vital
than any this country has known."* The FAP
was the main employer of artists during the
Depression and was decidedly non-elitist.
As broadly accessible art, posters fit the FAP's
philosophy well. Its poster divisions churned out
promotion for public institutions, including
FAP sibling programs for theatre, dance, music,
and writing (government arts support never
again reached this height in the U.S.). FAP posters
also addressed topical issues, e.g., workers' rights
and well-being. Here, Muchley merges man
and machine, demonstrating a strong grasp of
Cubism and other modern art movements.

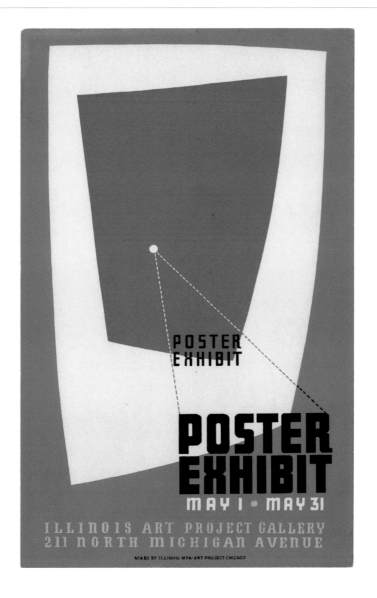

23

Designer Unknown

Poster Exhibit
ca. 1937
22 × 14 inches
Screen printing

PUBLISHER
WPA Federal Art Project
Illinois

PRINTER
Illinois Art Project
Chicago, IL

*Francis V. O'Connor in Christopher DeNoon,
Posters of the WPA
(Los Angeles: Wheatley Press, 1987), 7.

By 1938, the FAP was established in every state, with poster divisions in eighteen. This led to art exhibitions and classes attended by eight million people, many having no prior art exposure. It also led to two million posters printed from thirty-five thousand designs.* Here, a poster division promotes its own activities. An FAP innovation, screen printing heavily influences several modernist aspects of this poster, e.g., its flat colors and simplified, abstract shapes. But this unknown designer also uses other devices: a red, white, and blue palette connoting government patronage; a red poster-like shape, as the composition's "heart"; and asymmetry and typography reflecting Bauhaus influence.

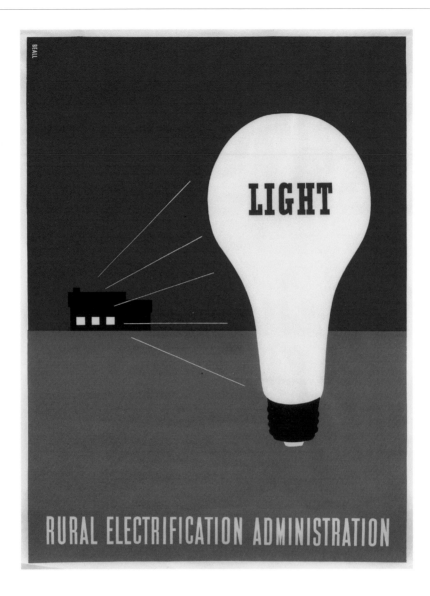

| 24 | **Lester Beall** | With a strong background in art history, Beall |

<table>
<tr><td>24</td><td>Lester Beall
1903–1969</td><td>With a strong background in art history, Beall translated European avant-garde movements into a distinctly American, precise modernism.*</td></tr>
</table>

24

Lester Beall
1903–1969

Light
1937
40 × 30 inches
Screen printing

PUBLISHER
U.S. Department
of Agriculture
Washington, DC

PRINTER
Unknown

*See R. Roger Remington, *Lester Beall: Trailblazer of American Graphic Design* (New York: W. W. Norton, 1996), 74–81.

With a strong background in art history, Beall translated European avant-garde movements into a distinctly American, precise modernism.* In each of the years 1937, 1939, and 1941, he designed a six-poster series promoting the Rural Electrification Administration. This New Deal agency was responsible for bringing cheap power to rural America, where eighty percent of the farms lacked electricity. This poster typifies the pictographic first series. In a red, white and blue composition, the promise of the government program is objectified in a monumental light bulb; and in a softer sell, light also emanates from the home, useful and comforting amidst Depression hardship and dislocation.

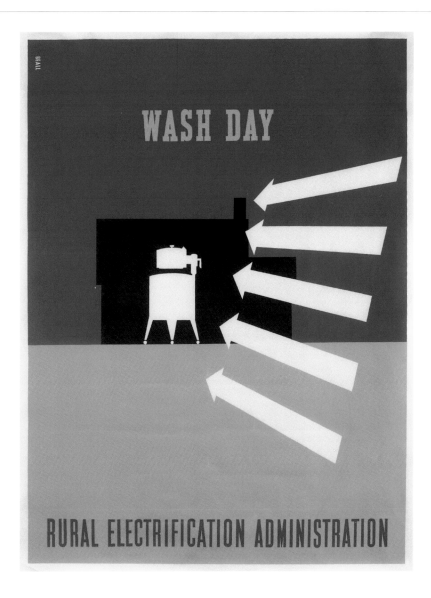

25

Lester Beall
1903–1969

Wash Day
1937
40 × 30 inches
Screen printing

PUBLISHER
U.S. Department
of Agriculture
Washington, DC

PRINTER
Unknown

The artistic significance of Beall's posters was immediately recognized and led to a 1937 solo exhibition at MOMA in New York, a first for an American graphic designer. The exhibition featured the iconic first REA series, in which Beall stripped form down to universal symbol. Straightforward yet sophisticated, the posters were lessons in semiotics immediately understood in the countryside and on Capitol Hill (the posters' main targets). Here, Beall shows another benefit of rural electrification: making domestic chores easier. The stark-white washing machine dominates the interior of the silhouetted farmhouse, emphasizing that the wash can now be done inside the home–with the hot running water electricity brings.

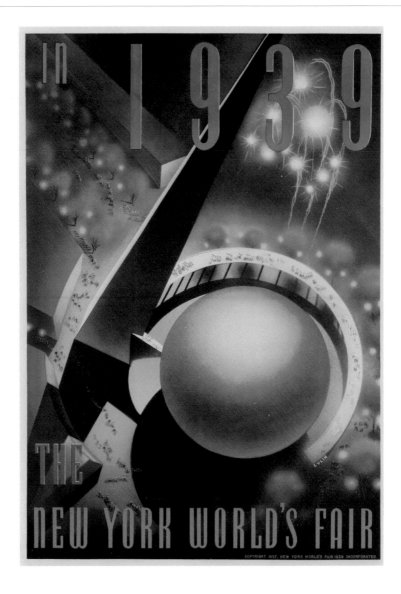

26

Nembhard N. Culin
1908–1990

In 1939 the New York World's Fair
1937
39¼ × 27⅝ inches
Photolithography

PUBLISHER
New York World's Fair
Corporation

PRINTER
Unknown

*John E. Findling and Sue Barry, "Nembhard Culin
and the New York World's Fair, 1939–1940"
(Paper presented at the PCA/ACA Conference,
New Orleans, April 17, 2003).

The colossal 1939 New York World's Fair required
advance publicity, including this poster. Official
fair themes were the "World of Tomorrow"
and "Democracy;" unofficially, the fair promoted
consumerism to quell the Depression. The fair's
aggressively utopian architecture and visionary
commercial displays sold those themes hard. At
the fair's center were the iconic Trylon, Perisphere,
and Heliceline–vast structures exemplifying
Deco's machine-age side, with their streamlined,
geometric shapes covered in plain white "skin."
An architect, Culin served on the fair's Board of
Design and also spearheaded his firm's design
of a pavilion.* His nighttime aerial view captures
the fair's dramatic, otherworldly nature,
and his airbrushing creates an appropriately
machine-like surface.

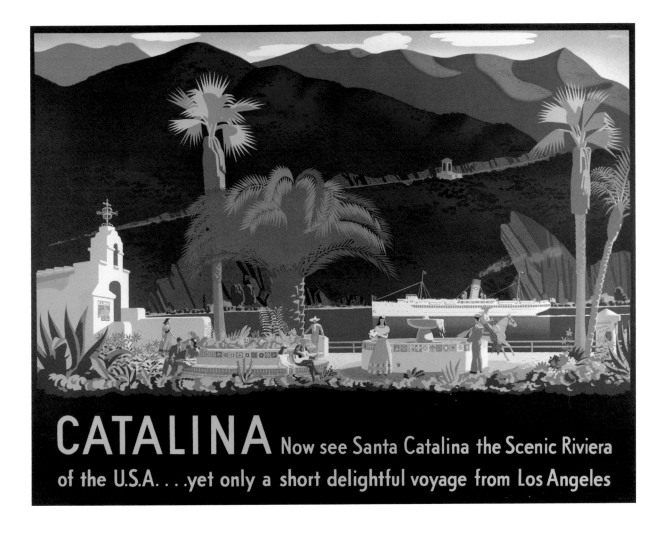

CATALINA Now see Santa Catalina the Scenic Riviera of the U.S.A. . . .yet only a short delightful voyage from Los Angeles

27

Otis Shepard

1894–1969

Catalina

1938
39 × 51 inches
Lithography

PUBLISHER
Wrigley Company
Chicago, IL

PRINTER
Unknown
Milwaukee, WI

Previously Foster & Kleiser's top creative executive, Shepard became the renowned art director of the Wrigley Company. In the early 1930s, his job was to "art direct" Wrigley-owned Catalina Island into a resort destination. Aided by his wife, Shepard spent four years on the island remaking the town of Avalon in a Spanish Colonial style. He did everything from city planning to landscaping, to designing street lamps, fountains, and tiles! This poster, reductive yet lush, sells the end product: a luxury resort rivaling those in Europe but within geographic, and thus financial, reach. Here, to reinforce the European comparison, Shepard follows the design of British Railway posters—large, horizontal, and picturesque.

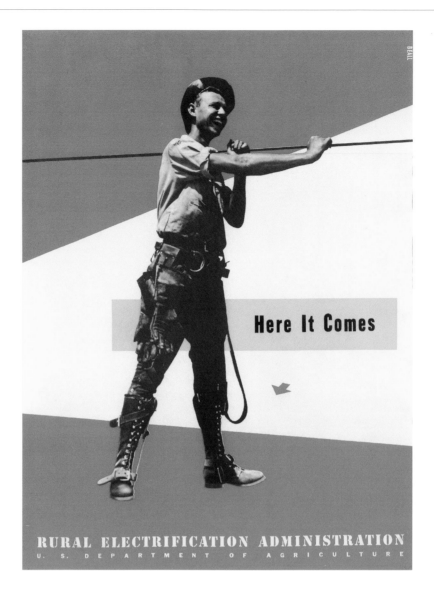

28

Lester Beall
1903–1969

Here It Comes
1939
40 × 30 inches
Screen printing and Photolithography

PUBLISHER
U.S. Department
of Agriculture
Washington, DC

PRINTER
Walling Process, Inc.
Washington, DC

Beall's first REA poster series emphasized electricity's role in meeting basic human needs (e.g., water, light, cleanliness, and moderation of the elements). He used a correspondingly basic, pictographic style featuring flat screen printing. Despite their humanist themes, these posters showed no people. The second poster series, however, showed technology's impact on actual users, a tendency toward realism that Beall reinforced by incorporating photography. This poster, a mix of photomontage and abstract screen-printed shapes, captures farmers' joy and excitement at the arrival of electricity. The electric cable, seemingly limitless given the poster's cropping, implies connection … to electrical current and, ultimately, between people.

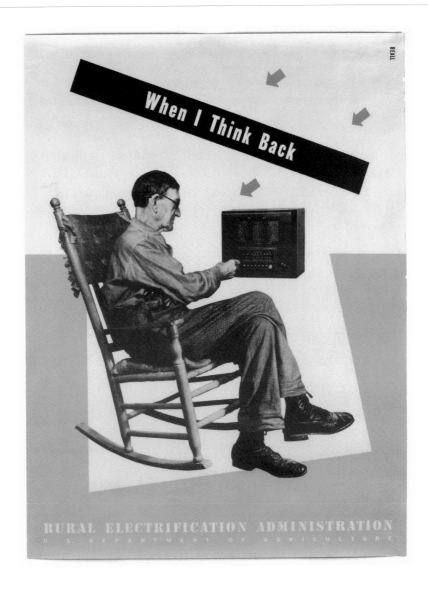

| 29 | **Lester Beall** | European artists started to use photomontage in |
| | 1903–1969 | the late teens. Prized for its ability to express the |

Lester Beall
1903–1969

When I Think Back
1939
40 × 30 inches
Screen printing and Photolithography

PUBLISHER
U.S. Department
of Agriculture
Washington, DC

PRINTER
Walling Process, Inc.
Washington, DC

*Sally Stein, "'Good Fences Make Good Neighbors:'
American Resistance to Photomontage Between
the Wars," in *Montage and Modern Life: 1919–1942*,
ed. Matthew Teitelbaum, 133–135
(Cambridge, MA: MIT Press, 1992).

European artists started to use photomontage in
the late teens. Prized for its ability to express the
dynamism, acceleration, and fragmentation of
modern life, photomontage dominated European
and Soviet visual culture in the 1920s and 30s;
but American designers largely resisted it due to
its foreign origins and Bolshevik connotations.*
Here, Beall excises an archetypal grandfather
from his original surroundings and places him
in a modern, color-block "shelter" incorporating
abstract shapes, typography, and Beall's signature,
eye-moving arrows. Instead of reading a book
or smoking a pipe as he rocks, the man enjoys a
still-new technology, radio, and wonders how he
managed without electricity.

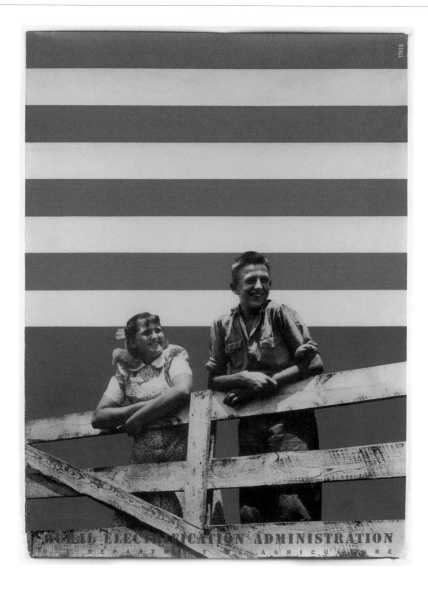

30

Lester Beall
1903–1969

Rural Electrification Administration
1939
40 × 30 inches
Screen printing and Photolithography

PUBLISHER
U.S. Department
of Agriculture
Washington, DC

PRINTER
Walling Process, Inc.
Washington, DC

The image speaks for itself in this almost-textless photomontage, a brilliant combination of realism and abstraction. These are "poster children" for the REA—happy beneficiaries of the program, in the present and future. Stylistically, the poster corresponds to the later third series, with its deconstruction of the American flag and its dense, interlocking elements. The flag motif serves several purposes. It signifies the overarching protection of the New Deal; the "matched" white stripes and fence rails subtly reinforce the connection between America and the farm; and it provides further visual interest, as the band of blue below the stripes somehow still functions as sky.

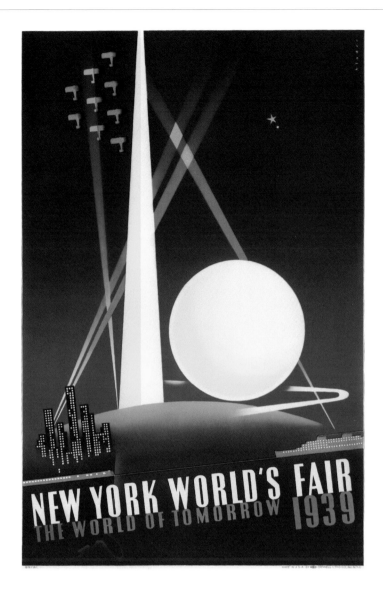

31

Joseph Binder
1898–1972

New York World's Fair 1939
1939
30¼ × 20 inches
Photolithography

PUBLISHER
New York World's Fair
Corporation

PRINTER
Grinnell Lithography Co., Inc.
New York, NY

*World Fairs & Expositions (Miami Beach, FL:
Wolfsonian-Florida International University,
2004), http://www.wolfsonian.org/collections/
c6/expos12.html.

The fair opened to a slowly subsiding Depression
and looming war, making the organizers' optimism
somewhat forced. They extolled modernism,
machines, and public-private sector partnership,
while declaring the fair's architecture "the keynote
of a perfectly-ordered mechanical civilization."*
Although unprofitable, the fair created employment,
boosted morale, and had worldwide cultural
impact. It also marked the zenith of the industrial
designer, whose recently-created profession
stimulated consumption through sweeping product
redesign. Binder's prize-winning poster, an icon of
streamlined Deco, captures the fair's dynamism:
atop the globe, the spotlighted fair is the
destination for every mode of mass transportation.
Binder's modernist image glorifies man's machines
and architecture while omitting man himself.

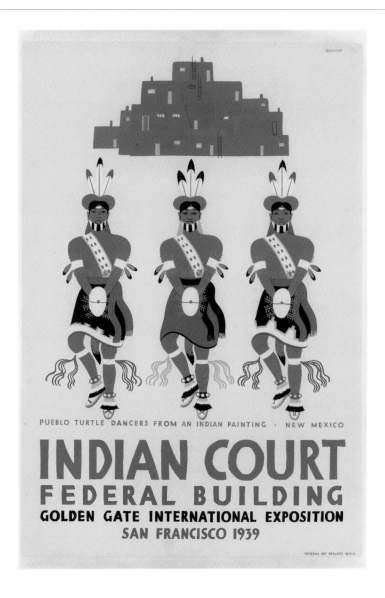

PUEBLO TURTLE DANCERS FROM AN INDIAN PAINTING · NEW MEXICO

INDIAN COURT
FEDERAL BUILDING
GOLDEN GATE INTERNATIONAL EXPOSITION
SAN FRANCISCO 1939

32

Louis B. Siegriest
1899–1989

Indian Court
1939
34 × 23 inches
Screen printing

PUBLISHER
Indian Arts and Crafts
Boards, u.s. Department
of the Interior
Washington, DC

PRINTER
WPA Federal Art Project
San Francisco, CA

*Larry Zim, Mel Lerner, and Herbert Rolfes,
*The World of Tomorrow; The 1939 New York
World's Fair* (New York: Harper and Row, 1988), 27.

The Golden Gate International Exposition
saw the opening of the eponymous bridge and
the end of the Depression fairs. Its "Pageant
of the Pacific" theme celebrated Pacific Rim
cultures, and its "Pacifica" architecture combined
the "modernism of Art Deco with the jungle
daydreams of Depression Hollywood."* Siegriest's
series of eight FAP posters promoted the "Indian
Court" exhibition–using a different image for
each tribe, based on Native American artwork.
The posters' bold, flat colors, along with symmetry
and distinctive pattern, produced strong graphic
works completely different from Siegriest's
renowned *plein air* paintings.

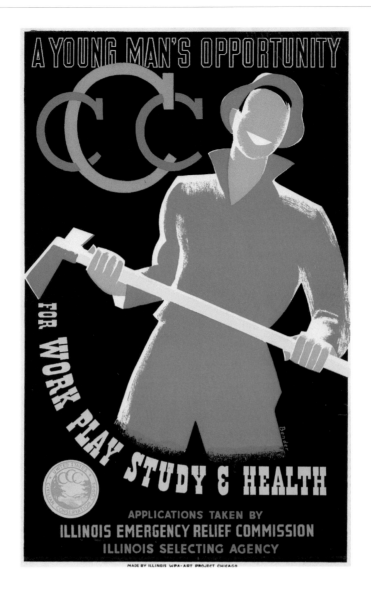

33

Albert M. Bender
dates unknown

CCC
A Young Man's Opportunity
1941
27¹⁵/₁₆ × 14 inches
Screen printing

PUBLISHER
Illinois
Emergency Relief
Commission

PRINTER
WPA Federal Art Project
Chicago, IL

The Civilian Conservation Corps employed five percent of the male population, mostly urban youths who earned a living while contributing to land conservation, state park expansion, and national recovery. The influence of Otis Shepard and Joseph Binder appears in this young man's almost-featureless face and techniques which make the flat screen-printing appear naturalistic. The poster's smaller dimensions are typical, reflecting cost concerns and the local nature of most FAP promotion (for which bold window placards sufficed). Such "smallness" diminished financial risk. This, along with government designers not worrying about their work increasing profit, allowed the *creative* risk-taking the FAP wished to encourage.

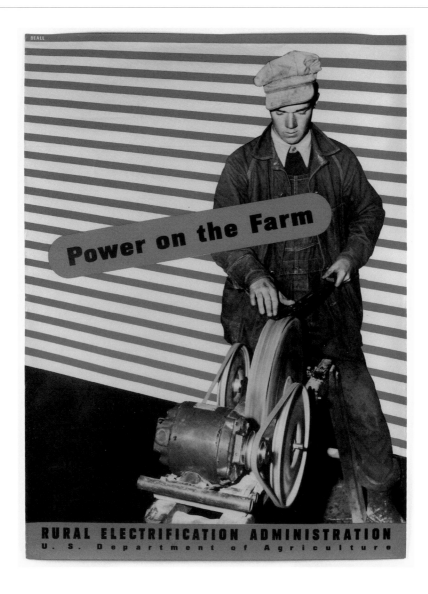

34

Lester Beall
1903–1969

Power on the Farm
1941
40 × 30 inches
Screen printing and Photolithography

PUBLISHER
U.S. Department
of Agriculture
Washington, DC

PRINTER
Unknown

In this third-series poster, Beall depicts the solitary, purposeful young man at the machine as a quiet hero of the farm (much as the woman in the next poster is a kind of domestic heroine). Electricity is his invisible yet dynamic assistant, symbolically rendered in blue, flag-like stripes that also serve as sky/background. Typical of this series, the poster is completely filled with image, much of it patterned, and text. The typography has changed from series to series, while the text has ranged from being a descriptive label (with less formal impact) to expressing individuals' speech or thoughts (in diagonal banners that are strong compositional elements).

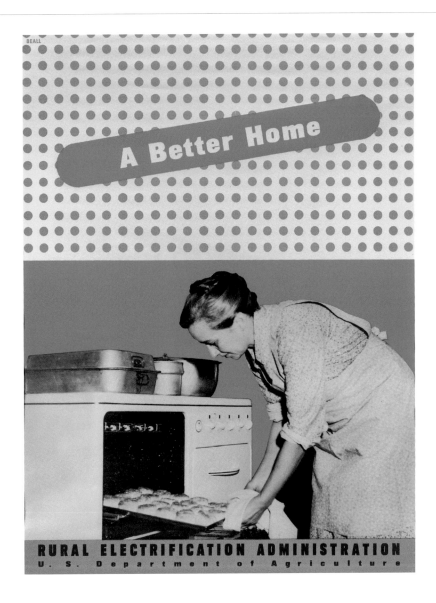

35

Lester Beall
1903–1969

A Better Home
1941
40 × 30 inches
Screen printing and Photolithography

PUBLISHER
U.S. Department
of Agriculture
Washington, DC

PRINTER
Unknown

*Beall in Remington,
Lester Beall: Trailblazer..., 109.

This third-series poster, again emphasizing electricity's tangible benefits, radiates well-ordered, abundant domesticity: from the contented housewife's perfect biscuits to the abstracted flag, in which stars are replaced by cheerful, feminine polka dots. Beall pushes the stylistic envelope over the course of the three series, showcasing his photography and unique approach to graphic design—characterized by reversals of expected imagery and scale, asymmetry, and masterful use of typography and symbols. Evident throughout is Beall's belief that art and design are indistinguishable and "applied good taste is a mark of good citizenship [while] ugliness is a form of anarchy."*

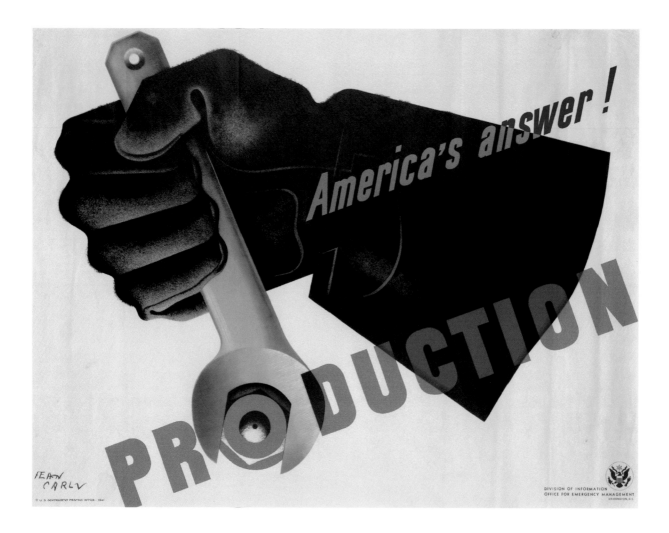

36

Jean Carlu
1900–1997

Production
1941
29¹⁵⁄₁₆ × 37⅞ inches
Photolithography

PUBLISHER
Division of Information
Office for
Emergency Management
Washington, DC

PRINTER
U.S. Government Printing Office
Washington, DC

World War II was the largest and deadliest military conflict in history. Although the U.S. did not enter the war until December 1941, in 1940 Roosevelt established the Office for Emergency Management to coordinate the "defense emergency." Posters were again key propaganda, though fully partnered this time with other media. Charles Coiner was appointed Art Consultant to OEM's Division of Information. Early on, "America's answer" was to produce material or its allies and defense. In perhaps the first government-issued World War II poster, Carlu brilliantly executes Coiner's preliminary design: the disembodied glove holds the "weaponry" of production, a poised wrench expressing the nation's about-to-be-unleashed energy.

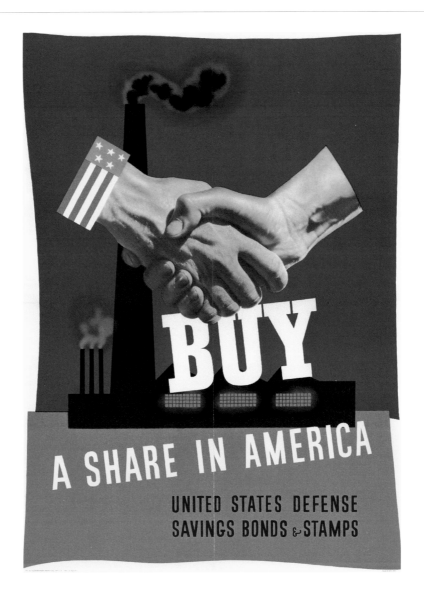

37

John Atherton
1900–1952

Buy a Share in America
1941
28 × 20 inches
Photolithography

PUBLISHER
U.S. Treasury Department
Washington, DC

PRINTER
U.S. Government Printing Office
Washington, DC

*David Kennedy, *Freedom from Fear: The American
People in Depression and War, 1929–1945*
(New York: Oxford University Press, 1999), 625.

A 1941 competition sponsored by MOMA in
New York brought leading-edge poster designs,
and their creators, to the attention of government
agencies struggling to maintain quantity and
quality. Still pre-war, the competition covered
only two categories but they were critical:
Treasury savings bonds (government borrowing
ultimately funded fifty-five percent of the war*)
and Army Air Corps recruitment. Atherton's
poster won first prize in the Treasury category,
and that summer the government issued it in
several sizes, including an enormous billboard
version. Reflecting the surrealism of Atherton's
paintings, the photomontage handshake
symbolizes the wartime partnership between
workers and government … and forms a victory
"v" over the all-important factory.

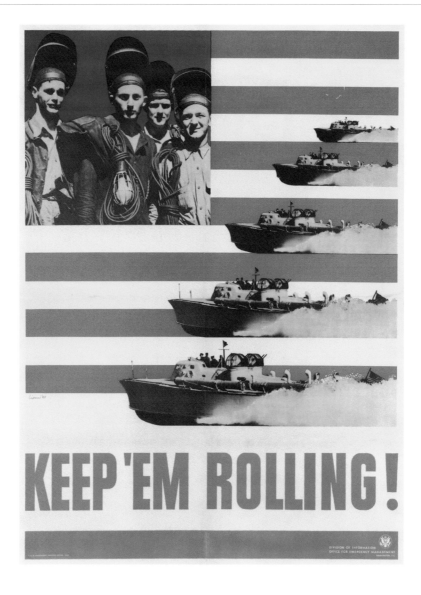

38

Leo Lionni
1910–1999

Keep 'Em Rolling
1941
40⅜ × 29¹³⁄₁₆ inches
Photolithography

PUBLISHER
Division of Information
Office for
Emergency Management
Washington, DC

PRINTER
U.S. Government Printing Office
Washington, DC

War preparedness required the quickest, largest buildup in history, triggering numerous "production-incentive" posters. This time Coiner tapped Lionni (the émigré he hired at Ayer) for a series of four posters. Each used the same layout: the flag's blue field contained a photograph of home front workers, and the product of their labor was shown on the war front, amidst red and white stripes serving as road, sky, or sea lanes. With the war still an abstraction for most Americans, these posters connected what happened "here" and "over there." They also reflected the wartime decline of expensive stone lithography and rise of photomontage–valued for its ability to convey war's reality, production overdrive, and a sense of crisis.

39

Herbert Matter
1907–1984

America Calling
1941
39⅞ × 29¾ inches
Photograph by Arthur H. Fisher
Photolithography

PUBLISHER
Division of Information
Office for
Emergency Management
Washington, DC

PRINTER
U.S. Government Printing Office
Washington, DC

Established to protect the population in case of attack, and headed by New York mayor Fiorello LaGuardia, the Office of Civilian Defense was largely Eleanor Roosevelt's brainchild. OCD reflected her view that social welfare programs were critical to national defense and the war was an opportunity to unite Americans and encourage volunteerism, especially among women and youths. A 1936 Swiss émigré to the U.S., Matter had helped to pioneer photomontage, and Coiner enlisted him to create this national defense image. Aloft on stripes evoking the flag and movement, the vigilant American eagle embodies the readiness, and obligation, to protect the country.

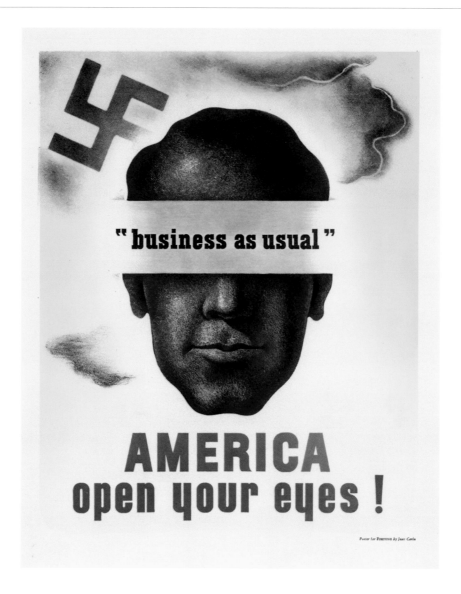

40

Jean Carlu
1900–1997

America Open Your Eyes
1941
14 × 11³/₁₆ inches
Photolithography

PUBLISHER
Time Incorporated
Jersey City, NJ

PRINTER
Unknown

In a summer 1941 *Fortune* issue devoted to the war, art editor Francis Brennan included a small portfolio of posters commissioned from leading designers (several of them "modernist émigrés" fleeing Europe). The posters were intended as exemplars of sophisticated yet effective "war graphics." Echoing Coiner, Brennan noted that the increased worldliness of Americans meant that "posters that moved [them] to lick the Kaiser would [now merely] arouse nostalgia for the days when war was simple and unsubtle." The text accompanying Carlu's surrealistic poster said: "Total war and 'business as usual' are logical opposites … Apathy, a false sense of security, a naive conception of international relationships, have blinded Americans."

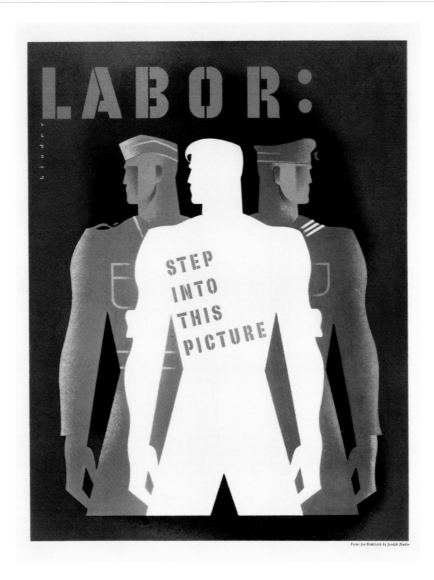

41

Joseph Binder
1898–1972

Labor: Step into This Picture
1941
13⅝ × 10¾ inches
Photolithography

PUBLISHER
Time Incorporated
Jersey City, NJ

PRINTER
Unknown

This *Fortune* poster addresses the production theme, with Binder exhorting labor to step into a "picture" already occupied by the military. From the accompanying text: "America is an industrial nation [whose] pre-eminent function in the war is as an arsenal of democracy… What labor must realize is that in total war every citizen, whether in or out of uniform, is a combatant; that [this is] a war of production and labor's role is even more crucial than that of the armed forces." The quality of Binder's work (he was Austria's premier poster designer before emigrating to the U.S.) again reflects Brennan's elevation of poster design standards.

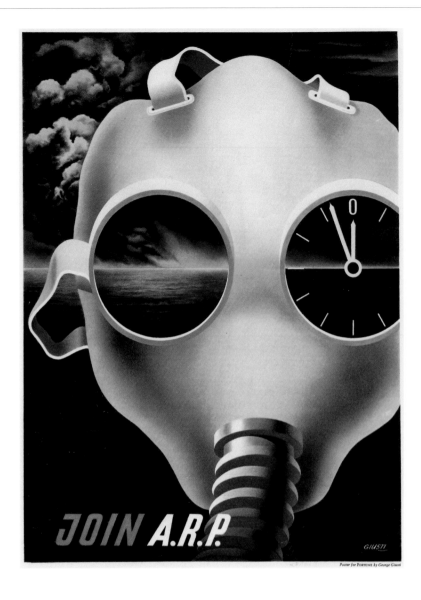

42

George Giusti
1908–1991

Join A.R.P.
1941
13½ × 10¼ inches
Photolithography

PUBLISHER
Time Incorporated
Jersey City, NJ

PRINTER
Unknown

*Francis Brennan, "A Portfolio of Posters,"
Fortune 24 (August 1941): 79.

Air Raid Protection was America's volunteer air-raid defense unit. In this *Fortune* poster depicting attack on the vulnerable coastline, Giusti evokes fear and urgency in a style that references Surrealism and the Swiss object poster. (An Italian émigré, Giusti also worked in Switzerland and on the 1939 New York World's Fair Swiss Pavilion.) Giusti, active in architecture and sculpture, considered graphic design a coequal among the arts, reflecting Brennan's view that: "Modern poster art is not a simple medium ... Criticism may be made that some [of these posters] are too sophisticated for general circulation [but] danger lies in ... underestimating rather than overestimating the public taste."*

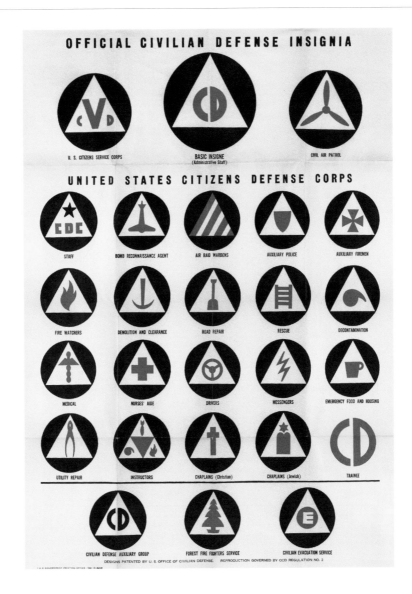

43

Designer Unknown

Official Civilian Defense Insignia
1942
40 × 28½ inches
Lithography

PUBLISHER
Office of
Civilian Defense
Washington, DC

PRINTER
U.S. Government Printing Office
Washington, DC

The December 1941 Japanese attack on Pearl Harbor and German declaration of war thrust America into combat. Demands on the OCD increased dramatically, as did turmoil within the agency. Eleanor Roosevelt's reaction to LaGuardia's apparent disinterest in various programs was to become his assistant. But after she helped the OCD get organized and negotiate vital interagency agreements, Eleanor convinced President Roosevelt to replace LaGuardia with James Landis. Meanwhile, she had spurred development of numerous OCD functions, with the insignia shown here. Coiner's visionary system of logo-like symbols—effective in its logic, geometric simplicity, and capacity for seemingly endless variation—anticipated universal pictogram and corporate identity programs which would flourish in the 1960s.

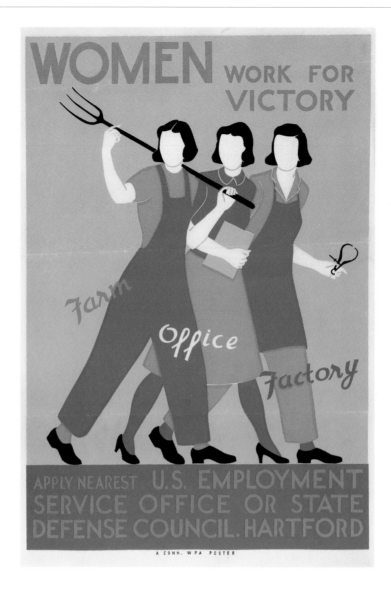

44

Designer Unknown

Women Work for Victory

ca. 1942
26⅛ × 17⅞ inches
Screen printing

PUBLISHER
U.S. Employment
Service Office/State
Defense Council
Hartford, CT

PRINTER
WPA Federal Art Project
Connecticut

*DeNoon, 108.

Many in Congress opposed President Roosevelt's work-relief programs, leveling exaggerated claims of waste and communist infiltration. From 1937, cutbacks proceeded steadily and, with the economy improving, only wartime propaganda needs forestalled termination of the FAP.
In this "home front soldiers" example, the designer's modernist approach skillfully presents the female workers as generic types. The FAP's legacy extended far beyond work-relief.
The agency "paved the way for public acceptance of abstract art, [referencing] European styles [while] developing a fresh style that was uniquely American," permeated with Social Realism and Regionalism.* It successfully balanced inclusiveness with quality and expanded the audience for art.

45

Glen Grohe
1912–1956

He's Watching You
1942
39¾ × 28⅜ inches
Photolithography

PUBLISHER
Division of Information
Office for
Emergency Management
Washington, DC

PRINTER
U.S. Government Printing Office
Washington, DC

*See William L. Bird, Jr. and Harry R. Rubenstein, *Design for Victory; World War II Posters on the American Home Front* (New York: Princeton Architectural Press, 1998), 27–31.

This poster figured in the "war graphics" versus "advertising" debate: should posters be sophisticated, stylized, and symbolic or highly accessible and illustrational? Madison Avenue's leading agencies convinced the government to conduct war poster "reaction surveys" in the industrial sector. "Data" from a few factories suggested that workers were confused by Grohe's modernist, anti-espionage poster (was "he" their boss?), thus supporting more literal work. In mid-1942, the Office of War Information was established to consolidate the propaganda functions of various agencies. Now OWI controlled the form and content of war messages. Although the modernist Brennan was in charge of graphics for the new agency, the style debate would persist.*

46

Clayton (?) Kenney
dates unknown

Civil Air Patrol
1943
28⅛ × 20⅞ inches
Photolithography

PUBLISHER
Office of
Civilian Defense
Washington, DC

PRINTER
U.S. Government Printing Office
Washington, DC

As head of OWI graphics, Brennan continued to push, amidst growing opposition, for modernist "war graphics" like this poster for the Civil Air Patrol. Among other activities, CAP's volunteer aviators combated German submarine strikes on Allied shipping (attacking 57 U-boats off the East Coast!). The CAP was part of the OCD, whose problems continued. Eleanor Roosevelt resigned from the OCD in 1942, frustrated that her official involvement drew political criticism to the agency (and eventually hobbled it). All that is known for certain of this poster's designer is his last name and squadron. Fortunately, his exceptional work speaks for itself.

47

Hubert Morley
dates unknown

Share
1943
27⅞ × 20 inches
Photolithography

PUBLISHER
U.S. Department
of Agriculture
War Boards
Washington, DC

PRINTER
U.S. Government Printing Office
Washington, DC

*Bird and Rubenstein, 40–41, 48.

Two factors in particular strengthened the hand of OWI's advertising men, leading to Brennan's resignation. First, they convinced bureaucrats that the move from defense to victory required a shift in style. Also, budget cuts meant that the OWI stopped designing posters and instead oversaw design by other agencies—an assembly-line approach that encouraged formulaic, literal depictions.* But in this poster, transitional between the old and new styles, Morley combines modernist, narrative, and Regionalist elements. A single word of text, and a tractor on fertile land undamaged by war, signify America's relative good fortune and obligation to help allies.

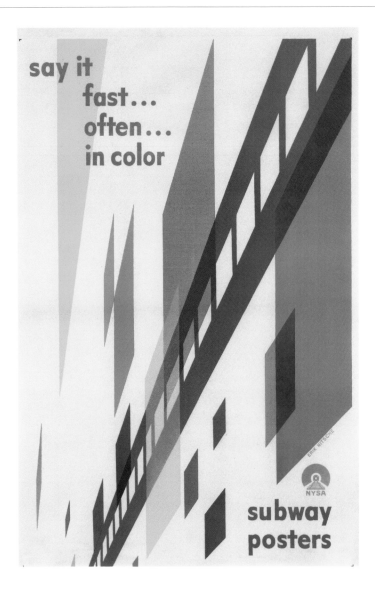

48

Erik Nitsche
1908–1998

Say It Fast ... Often ... In Color
1947
45 × 29⅝ inches
Lithography

PUBLISHER
New York Subways
Advertising Company
New York, NY

PRINTER
Unknown

*NYSAC advertising card, late 1940s.

Finally ended in 1945, World War II brought profound geopolitical, economic, cultural, and technological change. Despite the rise of other media, the poster had enjoyed a special wartime role. But post-war, the poster would be overshadowed by radio, movies, periodicals, and then television–making even more remarkable this 12-poster campaign promoting subway advertising. The NYSAC promised the display of ads "24 hours a day, before New York's subway riding millions ... near thousands of retailers [and with] a unique combination: color ... repetition ... coverage."* Nitsche's rhythmic, semi-abstract composition–a stylized subway car/track slicing through floating color-block "posters"–conveys the trains' speed and the ads' vibrancy.

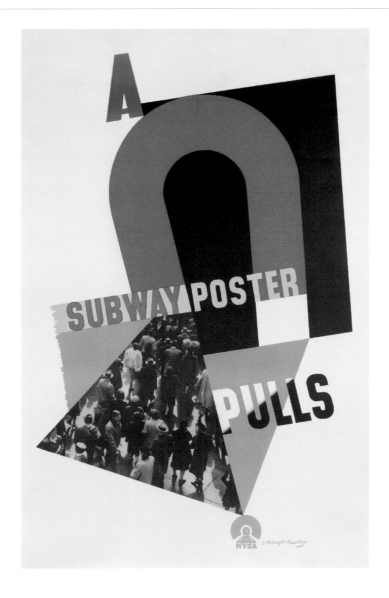

49

Edward McKnight Kauffer
1890–1954

A Subway Poster Pulls
ca. 1948
45¾ × 30⁵⁄₁₆ inches
Lithography

PUBLISHER
New York Subways
Advertising Company
New York, NY

PRINTER
Unknown

An American, Kauffer lived in England from 1914–1940 but returned home to contribute to the war effort. Initially a painter, he was also an illustrator and a set, costume, and textile designer. Above all he was a graphic designer, renowned for posters that merged modern art and advertising. Here, a magnet "tunnel" pulls in a mass of subway riders (a.k.a. consumers) contained in a Constructivist, photomontage wedge. Trains and posters are inferred but not shown. This poster exemplifies the series: it is designed by a world-class artist; complex, it benefits from the scrutiny of a captive subway audience; and it is ambitiously executed, in a mix of printing processes.

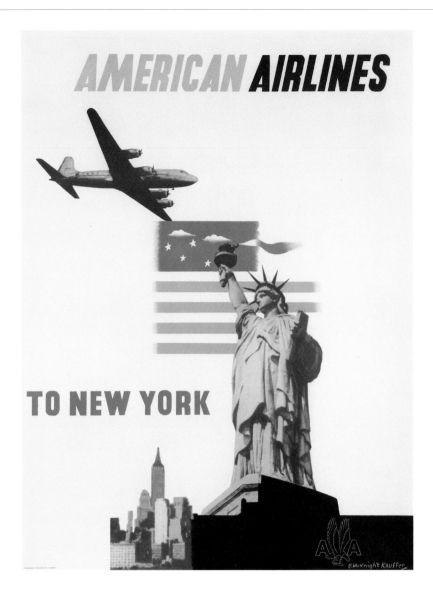

50

Edward McKnight Kauffer
1890–1954

American Airlines to New York
1948
39¾ × 30¼ inches
Photolithography

PUBLISHER
American Airlines

PRINTER
Unknown

*Steven Heller, "The Essential Modernist,"
 (New York: AIGA, 1992), http://www.aiga.org/
 content.cfm?contentalias=emcknightkauffer.

Kauffer missed England, where he was exalted,
and was generally unhappy working in American
advertising. He was "adrift in a fast-paced,
competitive New York [and didn't] develop the
intimate artist/client relationships that,
in England, allowed him to push conventions."
Although he received major commissions, in late
1940s America the "essential Modern poster ...
was acceptable on a museum wall but [generally]
not on the street."* Kauffer reluctantly
accommodated that bias but not in this poster,
which is modernist and full of unconventional
elements (e. g., the transitional flag/sky,
yellow "highlighted" attractions of Manhattan,
and diagonal axis comprised of horizontal
and vertical elements).

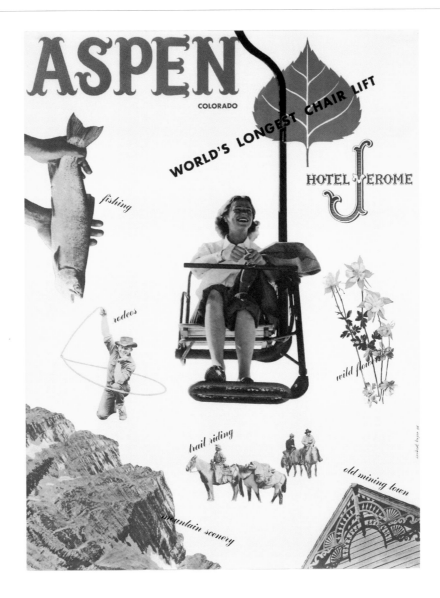

51

Herbert Bayer
1900–1985

Aspen
1948
39⅞ × 30⅛ inches
Photolithography

PUBLISHER
Aspen Ski Corporation
Aspen, CO

PRINTER
Unknown

A student and teacher at the Bauhaus, Bayer instigated the signature style of its publications: well-ordered, economic, and using his own sans serif, lower-case type. Emigrating to the U.S. in 1938, Bayer lived the Bauhaus ideal of art integrated into life. His resumé expanded to include photography, painting, and sculpture, and environmental, exhibition, and textile design. Bayer's print work for Container Corporation of America landed him the job of remodeling/designing Aspen as a year-round resort and cultural center. Here, Bayer promotes the town's off-season attractions. The Bauhaus master mixes quaint and modernist elements, balances negative space with complicated text and image, and deftly manipulates scale.

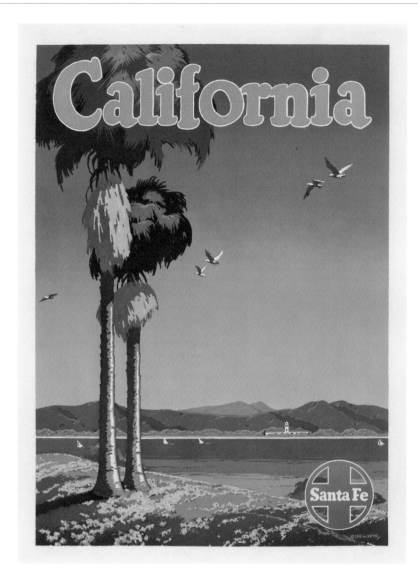

52

Oscar M. Bryn
1883–1967

California
ca. 1949
24 × 18 inches
Photolithography

PUBLISHER
Atchison, Topeka,
and Santa Fe Railway
Chicago, IL

PRINTER
Unknown

*See Zega and Gruber, 41–46, 74.

Bryn freelanced with the Santa Fe railroad from 1914 on. He and Louis Treviso designed thecompany's earliest posters, transforming Santa Fe's print-advertising norm of straight realism. Bryn eliminated unnecessary detail and used bold composition and even bolder color to create vivid, effective ads. This "destination poster" is from Santa Fe's last major poster campaign. Showcasing the iconic palms, beaches, and Spanish architecture of Bryn's home state, it evokes posters from the railroad's heyday. Yet that heyday was virtually over, subdued by wartime delays and crowding, the automobile, and now the airplane. In 1952, more people would travel by plane than Pullman car.*

famous brands of the Lone Star State

| 53 | **Designer Unknown** | This poster is from the same campaign as the previous example, but targets freight customers. No beautiful vacation spot beckons. Instead, the poster associates the railroad with products that require land transportation, with a background color evoking cattle and sun-baked earth. The image is a variant of a print ad, which noted: "These brands ... stand for cattle. But look closer and you'll see a 'brand' that stands for a long-time Texas partner in getting those cattle [and more] to market. It's the Santa Fe trademark."* Taken together, these vernacular cattle brands are as impressive as the best "designed" systems of pictograms. |

Texas
ca. 1949
24 × 18 inches
Photolithography

PUBLISHER
Atchison, Topeka,
and Santa Fe Railway
Chicago, IL

PRINTER
Unknown

*Atchison, Topeka, & Santa Fe, Ads of Yesteryear
(QStation.org, 2001), http://www.qstation.org/
Ad_Access/1945.html.

ASSOCIATION OF AMERICAN RAILROADS, WASHINGTON 6, D. C.

54

Joseph Binder
1898–1972

The Most Important Wheels in America
1952
18 × 14 inches
Photolithography

PUBLISHER
Association of
American Railroads
Washington, DC

PRINTER
Unknown

Although passenger travel had waned, collectively the railroads still dominated freight transportation. Binder's poster, on behalf of an industry-wide association, drives home that point. Instead of depicting an exotic tourist destination or particular rail company, he shows a generic freight train—in an airbrushed style that lends the machine Cassandre-esque glamour. The low-lying close-up and vanishing-point perspective emphasize the train's mass, power, and speed, while the patriotic colors remind us of the railroad's strategic importance to the nation, in war or at peace.

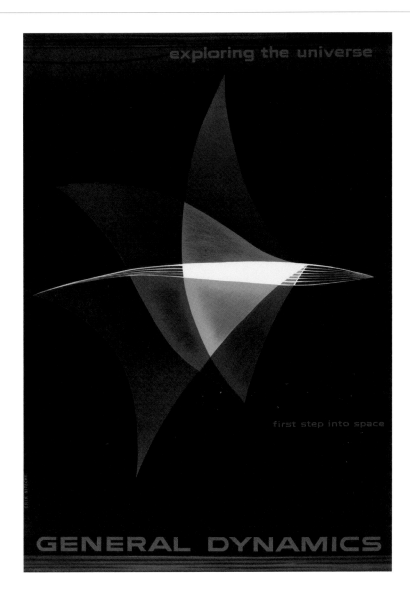

55

Erik Nitsche
1908–1998

General Dynamics
1957
50⅛ × 35½ inches
Lithography

PUBLISHER
General Dynamics
Corporation
Falls Church, VA

PRINTER
Lithos R. Marsens
Lausanne, Switzerland

*Steven Heller, "A Contemporary Man," *Print* 52
(January–February 1998): 104–110, 220.

The partition of Europe into Western and
Eastern spheres of influence after World War II
set the stage for the Cold War. Both conflicts
underscored nuclear power's destructive potential,
but General Dynamics wished to convey its
peaceful and progressive benefits—symbolically,
as the company's top-secret work could not be
explicitly depicted. (GD's work ranged from
defense equipment to astronautics to hydro-
dynamics.) Nitsche's decade-long advertising/
identity program did that and more. It portrayed
complex science elegantly yet accessibly and
without sci-fi gimmickry, establishing a highly
influential visual idiom.* This poster, like many
others he designed for GD, reflects Nitsche's Swiss
orderliness and more "intuitive" training in France.

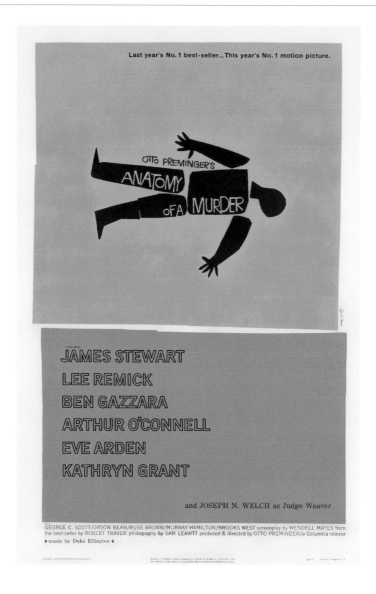

56

Saul Bass
1920–1996

Anatomy of a Murder
1959
40¹³⁄₁₆ × 27³⁄₁₆ inches
Lithography

PUBLISHER
Columbia Pictures
Corporation
New York, NY

PRINTER
Unknown

Bass revolutionized movie marketing. His logo-like "key art" distilled a movie into a single compelling image that drove the entire print campaign. His screen titles, beyond displaying credits, were kinetic graphic design that deftly established the movie's themes. This classic poster's key art–a murder victim's silhouetted body incorporating the movie's title–is imposed on the upper color field. Inconceivable today, the stars are not pictured and their names, in "see-through" type, are subordinate on the lower field. The split, Rothko-esque color fields evoke the heated emotions in the courtroom and echo the segmented, "anatomical" rendition of the body… which in turn suggests the complicated pieces of the crime and justice system.

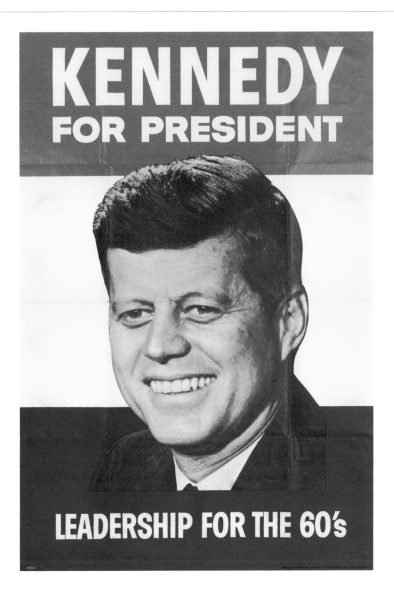

57

Designer Unknown

Kennedy for President
1960
41 × 27⅞ inches
Lithography

PUBLISHER
Citizens for
Kennedy and Johnson
Washington, DC

PRINTER
Amalgamated
Lithographers of America
Chicago, IL

Kennedy's upbeat and handsome young face, set against the colors of the flag, reflected Americans' optimism at the start of the decade. But as the tumultuous era slowly unfolded–becoming "The Sixties"–optimism turned to widespread disillusionment. Americans were buffeted by assassinations (JFK, Malcolm X, MLK, RFK); an increasingly violent civil rights movement; the counterculture "revolution;" and the Vietnam War, an outgrowth of the ongoing Cold War that dominated Kennedy's presidency. This upheaval stimulated a poster revival, with thousands of works "getting the message out" cheaply, broadly, and provocatively. Printing was inexpensive, grassroots distribution was free, and the medium fit the era's rebelliousness and emphasis on self-expression.

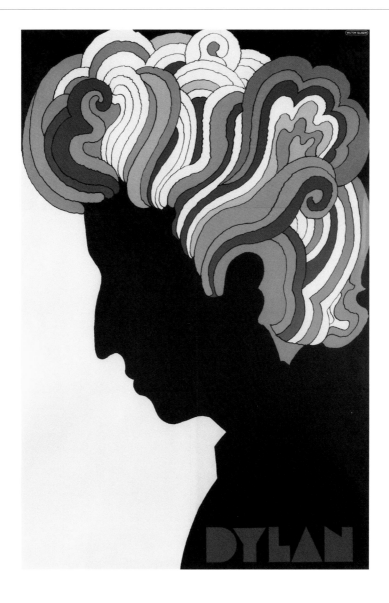

58

Milton Glaser
1929–

Dylan
1966
33 × 22 inches
Lithography

PUBLISHER
Columbia Records
New York, NY

PRINTER
Unknown

* Milton Glaser, *Graphic Design*
(Woodstock, NY: Overlook Press, 1983), 50.

Rock was the youth movement's soundtrack. Acoustic rock roused the activists, providing anthems for the civil rights and anti-war movements. Electric rock pulsed through the psychedelic counterculture, as young people "tuned in, turned on, and dropped out," disengaging from a society they believed was bent on its own destruction. Bob Dylan, reluctant activist figurehead and guru for a generation, straddled both sides of rock's line. This poster, a *Greatest Hits* album insert, reflects the eclecticism for which Glaser's Push Pin Studios was renowned: Duchamp-influenced silhouette, psychedelic hair inspired by Islamic painting, and Glaser's own "Baby Teeth" type.*

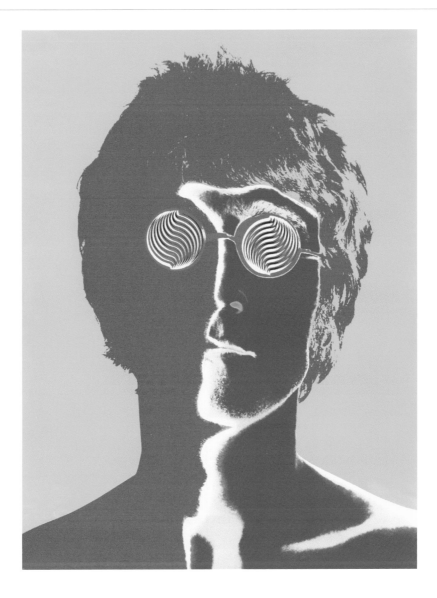

59

Richard Avedon
1923–2004

John Lennon
1967
31⅛ × 22½ inches
Lithography

PUBLISHER
Cowles Education
Corporation/Richard
Avedon Posters, Inc.
New York, NY

PRINTER
Unknown

From clean-cut to counterculture, the Beatles' transformation mirrored that of America's youth. By 1967, the Beatles were the most famous rock band ever. They embodied the "sex, drugs, and rock and roll" platitude but also deeper aspects of the counterculture. Avedon, who had made fashion photography an art and was the era's premiere photographer of cultural figures, captured the band at its height in photos for *Look Magazine*. Also issued as posters, the photos made psychedelic use of Dadaist Man Ray's solarization technique, while bringing out each band member's distinct character. Given the Beatles' fame, and that they were the only "product" being promoted, no text was necessary.

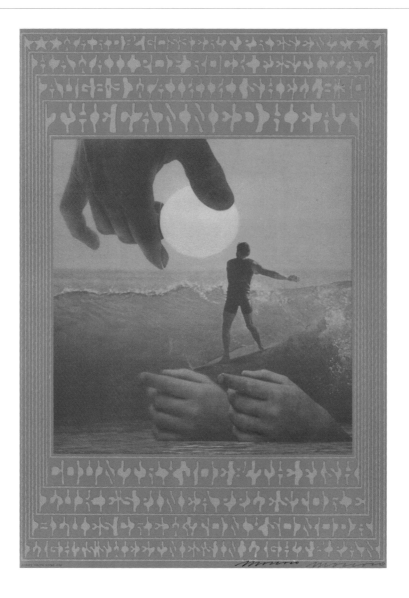

60

Victor Moscoso

1936–

Hawaii Pop Rock Festival

1967

20 × 14 inches

Lithography

PUBLISHER
Neon Rose
San Francisco, CA

PRINTER
Unknown

The counterculture originated with San Francisco's hippies, peaking there during the "Summer of Love" (1967). A reaction against Cold War-era conservatism and the Vietnam War, the movement was fueled by the birth control pill, drugs, music, and non-Western goods and ideas. Psychedelia was the counterculture's visual code. Moscoso churned out brilliant, "trippy," intentionally difficult to grasp "anti-posters" for local dance concerts. He could turn the medium on its head, creating a unique style, because he had mastered so many influences. These included Art Nouveau and vernacular design, surrealistic photomontage, and the Bauhaus color theory (learned at Yale from Josef Albers) which informed his vibrating, LSD-inspired color combinations.

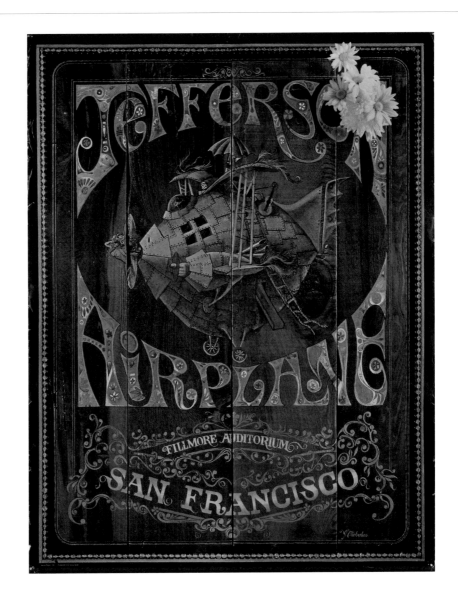

61

Jim Michaelson

1941–

Jefferson Airplane

1967
40 × 30 inches
Lithography

PUBLISHER
David Schiller
Sparta Graphics
San Jose, CA

PRINTER
Penninsula Lithograph
Menlo Park, CA

This poster was designed by illustrator Jim Michaelson as a "deluxe" version of a poster designed for a 1966 San Jose dance. The original illustration, painted on wood behind a gas station on San Jose's Santa Clara Street, was carted up to San Francisco for approval by Bill Graham, the new manager for the rock group Jefferson Airplane. A quiet moment was chosen, and then a sheet was dramatically lifted to reveal this beautiful work of art. According to anecdote, Graham was ecstatic, and it became one of his all-time favorites out of the many concert posters produced during the late 1960s for the band. Michaelson's deft handling of the lettering and ornamentation make this an American original and very much an expression of the San Francisco rock scene.

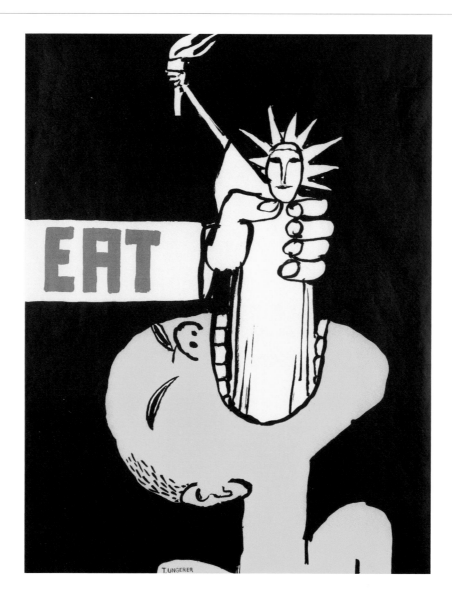

62

Tomi Ungerer
1931–

Eat
1967
26⅝ × 20¾ inches
Lithography

PUBLISHER
Tomi Ungerer/
Richard Kasak
New York, NY

PRINTER
Unknown

Amidst the Cold War, the U.S. sought but failed to prevent communism's spread in Southeast Asia, particularly from North Vietnam (backed by the USSR and China) to South Vietnam. Pursued aggressively by presidents Johnson and Nixon, the Vietnam War was the first military loss in U.S. history. Millions, largely Vietnamese, died. By 1967, Johnson had increased Kennedy's fourteen thousand troops to about five hundred thousand, and the anti-war movement was well underway. Many perceived the U.S. intervention as repressive paternalism, unwarranted meddling in a sovereign country's civil war, and outright imperialism—themes Ungerer drives home in this depiction of American-style "liberty" being force-fed to an Asian man.

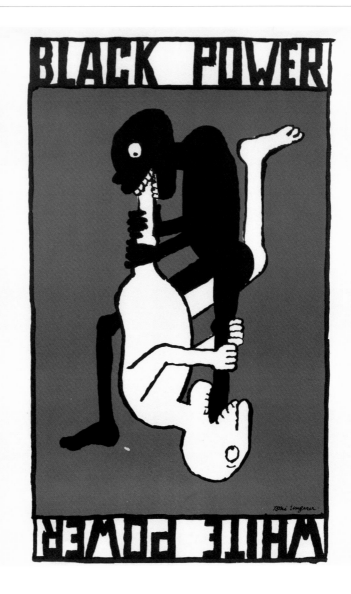

63

Tomi Ungerer
1931–

Black Power White Power
1967
28⅛ × 21⅝ inches
Lithography

PUBLISHER
Tomi Ungerer/
Richard Kasak
New York, NY

PRINTER
Unknown

During 1954–1968, under Martin Luther King's leadership, African Americans made great progress against discrimination: from the 1954 *Brown vs. Board of Education* decision (prohibiting segregation in public education) to the 1964–1968 Civil Rights Acts. But by the latter 1960s, "Black Power" groups broke with King, urging separation from whites ("devils," per Malcolm X) and that violence be met with violence. "White Power" groups surfaced, strongly resisting blacks' progress. Ungerer, ever the outsider immigrant willing to counter even fellow progressives, saw black and white extremists as equally dangerous. This poster, which can be viewed with either race on top, depicts a perfect, vicious circle of all-consuming racism.

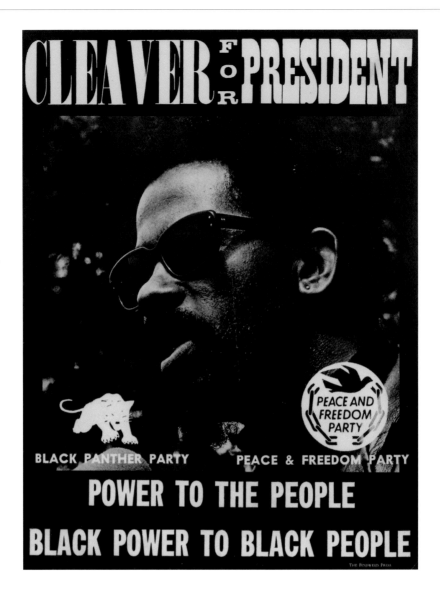

64

Designer Unknown

Cleaver for President
1968
22⅛ × 16⅝ inches
Photolithography

PUBLISHER
Black Panther Party/
Peace & Freedom Party

PRINTER
Bindweed Press
San Francisco, CA

The Black Power movement drew from those who objected to King's ideology of non-violence, his greater focus on the rural south, and his involvement of whites. Founded in 1966, the Black Panthers, heavily urban, followed many of Malcolm X's tenets. They also challenged police brutality "by any means necessary," including armed confrontation. Their alliance with the Peace and Freedom Party resulted in the 1968 presidential nomination of Eldridge Cleaver, Panther spokesperson and celebrated author of *Soul on Ice* (which Cleaver wrote while in prison). In this highly unusual campaign poster, there is no red white and blue, or smiling face. Instead, black and white reinforces the Black Power theme and Cleaver's gritty, cool toughness.

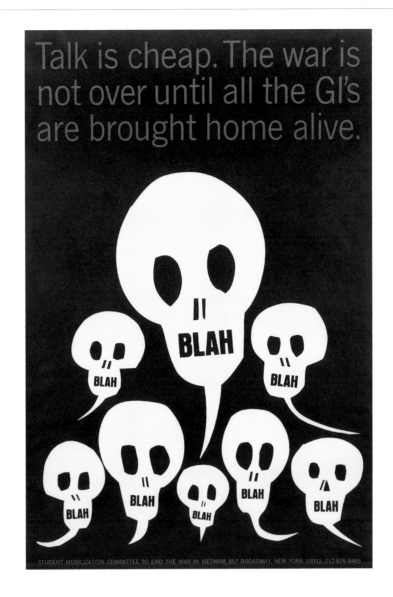

65

Designer Unknown

Talk is Cheap
ca. 1968
26⅞ × 18 inches
Lithography

PUBLISHER
Student Mobilization
Committee to
End the War in Vietnam
New York, NY

PRINTER
Union
New York

The year 1968 was a turning point in the rapidly escalating war/anti-war movement. In February, Tet Offensive casualties ignited demonstrations nationwide. In March, having barely won a Democratic primary over peace candidate Eugene McCarthy, President Johnson withdrew his re-election candidacy and announced peace talks in Paris. But when the talks failed, many Americans concluded they were a ploy to ease domestic tensions. Hence this SMC poster's declaration that "talk is cheap"—with the deathmongers' babble emanating from speech-balloon skulls. With a militant platform of immediate withdrawal, the SMC was the national, student wing of the antiwar movement. Its "mobilizations" included several marches of 1 million strong, the largest in U.S. history.

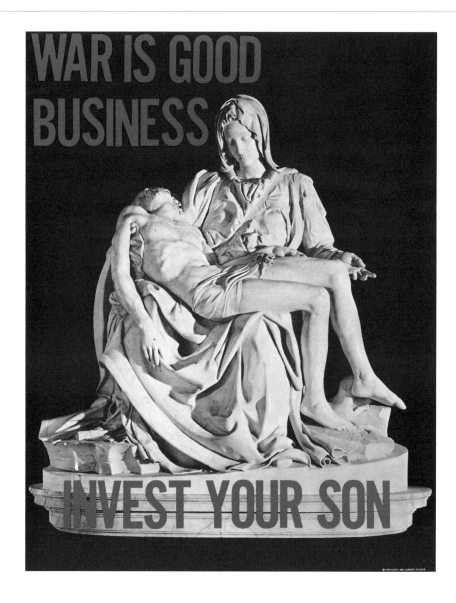

66

Designer Unknown

War is Good Business
1969
28 × 22 inches
Lithography

PUBLISHER
Lambert Studios, Inc.

PRINTER
Unknown

Claiming support by "the silent majority," newly-elected President Nixon pursued a policy of "slow disengagement." The policy was intended to give South Vietnam time to take up the military slack, and to decrease the uproar at home. Yet heated protest continued, as did accusations about the war's real motivations. This poster highlights the supposed cozy relationship among the Pentagon, private-sector suppliers, and Congress—the "military-industrial complex" of which President Eisenhower warned. The Pieta is particularly apt, given the substantial activist bloc that mothers comprised and this poster's message that young men were "dying for the sins" of their government. Posters were the opposition's low-tech, subversive retort to nightly, Pentagon-dominated television coverage.

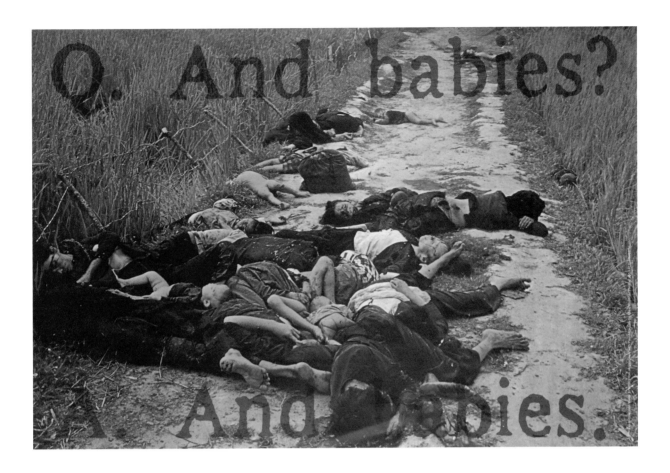

67

Peter Brandt
dates unknown

Q. And Babies? A. And Babies.
1970
25 × 38 inches
Photograph by Ron L. Haeberle
Photolithography

PUBLISHER
Art Workers Coalition
New York

PRINTER
Amalgamated Lithographers
New York

On March 16, 1968, American soldiers massacred hundreds of unarmed civilians in the Vietnamese village of My Lai. The victims, some also tortured or raped, were mostly women and children– not the Vietcong battalion the village supposedly harbored. Following a lengthy cover-up, only one soldier was convicted; Nixon pardoned him. This widely-disseminated poster evoked compassion and provided proof of an atrocious war. Along with the bombing of Cambodia and Laos, the massacre fueled protest of unprecedented breadth, jump-starting "slow disengagement." By early 1973, U.S. withdrawal was complete and the North's victory assured. The war's legacy was complicated: Americans were more cynical about their government's actions, yet assured of mass dissent's role and power in a democracy.

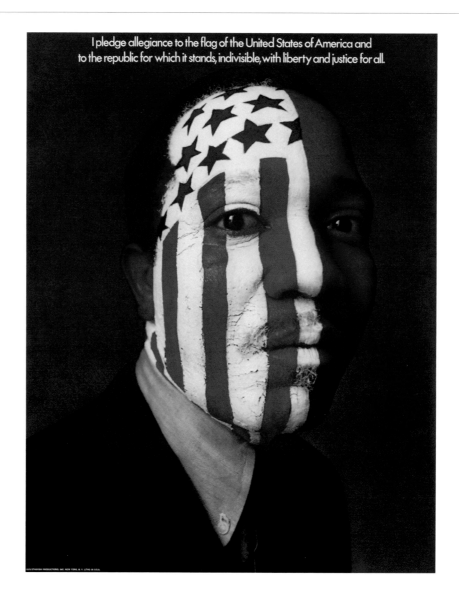

I pledge allegiance to the flag of the United States of America and to the republic for which it stands, indivisible, with liberty and justice for all.

68

Designer Unknown

I Pledge Allegiance
1970
28 × 22 inches
Photograph by Ron Borowski
Photolithography

PUBLISHER
Starfish Productions, Inc.
New York, NY

PRINTER
Unknown

Despite major gains, the circumstances of African-Americans remained difficult. With King's 1968 assassination, ensuing riots worsened the living conditions of many blacks and the civil rights movement was eclipsed by the less effective (although symbolically potent) Black Power movement. Moreover, blacks continued to be disproportionately drafted. In this poster, the black man's half-painted face captures the incongruous situation of African Americans: they were exhorted to pledge allegiance yet often treated like "half-citizens." The man's face reflects an unhappy mix of alienation, ambivalence, and anger. "Acting the part," symbolized by the reverse-minstrel face painting, will never win this man full acceptance in white America … and may well undermine him in the black community.

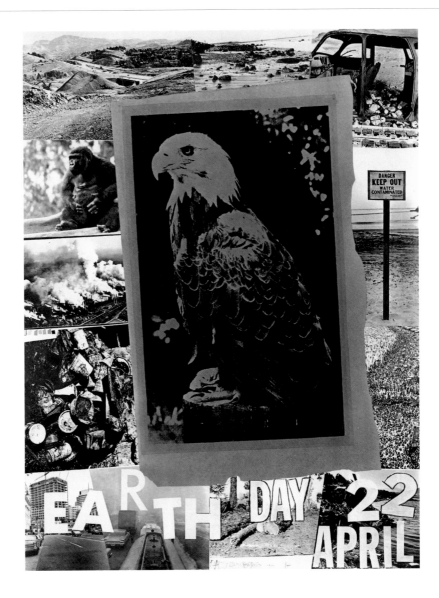

69

Robert Rauschenberg

1925–

Earth Day 22 April

1970

33⅝ × 25¼ inches

Photolithography

PUBLISHER

Castelli Graphics

New York, NY

PRINTER

Unknown

Using experience gained in 1950s and '60s civil rights and anti-war protests, the youth movement again drove activism in the 1970s. Environmentalism was one of a plethora of causes. It was heavily influenced by the 1960s' counterculture, sense of a world on the brink, and greater awareness of the earth as a whole (heightened by the space program's unprecedented photographs). In this poster for the first Earth Day, celebrated fine artist Rauschenberg juxtaposes the American eagle–whose endangered-species status connotes national jeopardy–with a collage of gritty photographs documenting a fouled environment.

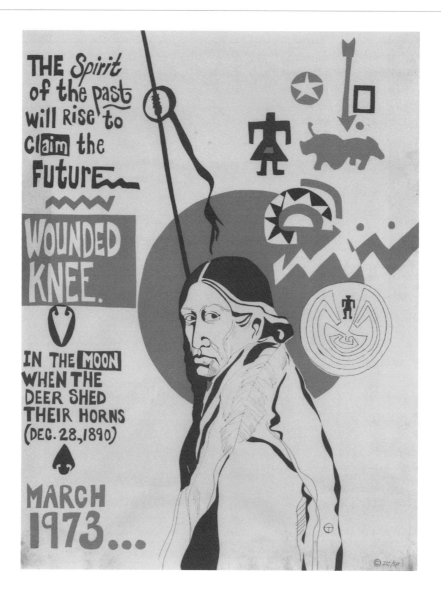

70

Designer Unknown

Wounded Knee
1973
25⅛ × 19 inches
Screen printing

PUBLISHER
American Indian
Movement (AIM)
Minneapolis, MN

PRINTER
Unknown

In 1973, led by AIM members, Sioux from Pine Ridge Reservation occupied the reservation town of Wounded Knee, South Dakota, to protest the tribal chairman's corruption and indifference. He summoned federal authorities, leading to a 71-day armed standoff and the airing of much larger grievances—especially the charge that the government had made a grossly unfair proposal to settle the reservation's claim to the Black Hills. The protestors chose Wounded Knee, where the army massacred several hundred Sioux in 1890, because it symbolized oppression of Indians and confiscation of their land. Past and present wrongs, and future rectification, are alluded to in this earth-and-blood-toned poster ... and connecting all of them is the sacred land of Wounded Knee.

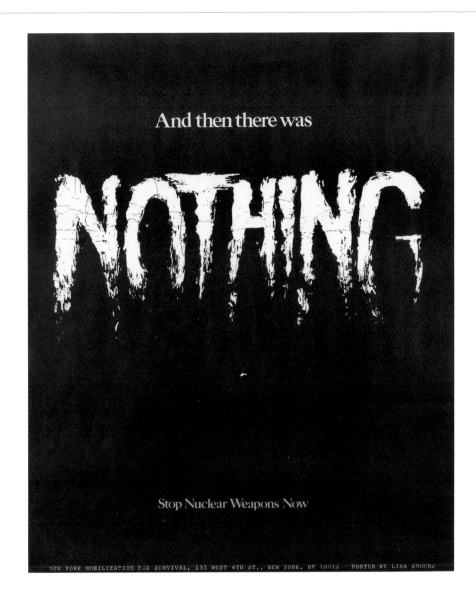

71

Lisa Emmons
dates unknown

And Then There Was Nothing
ca. 1974
24½ × 20 inches
Photolithography

PUBLISHER
New York Mobilization
for Survival
New York, NY

PRINTER
Unknown

The atomic bombing of Japan was followed by military nuclear accidents, the arms race, the Cuban Missile Crisis, and development of the nuclear power industry. After decades of effort, negotiations to reduce nuclear arsenals were still nascent; and nuclear power's safety remained a major concern. During the 1970s, such anti-nuclear groups as the national Mobilization for Survival (MOBE) brought together peace activists and environmentalists. MOBE's goals were complete nuclear disarmament, a ban on nuclear power, and redirection of money from arms to human needs. The minimalism of this disarmament poster perfectly captures the nightmare of nuclear holocaust, and Emmons's inventive, "disintegrating" type, emerging from the black void, hauntingly evokes skeletal decomposition.

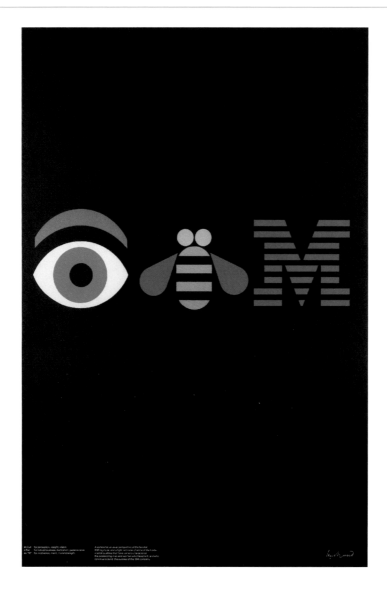

Paul Rand

1914–1996

IBM

1981

36 × 24 inches

Photolithography

PUBLISHER
International Business
Machines
White Plains, NY

PRINTER
Unknown

*"Paul Rand Biographical Profile,"
RIT *Design Archive Online* (Rochester, NY:
Rochester Institute of Technology, 1996),
http://design.rit.edu/biographies/rand.html.

Reflecting European avant-garde and American influences, Rand's distinct style was "characterized by simplicity, wit, and a rational approach."*
The post-World War II growth of multinational conglomerates spurred corporate identity programs. Rand was at the top of the field, designing logos for IBM, Westinghouse, UPS, ABC, etc. His 40-year relationship with IBM started in 1956 with an overhaul of the company's graphics. IBM was poised to take off and soon there seemed to be an equation of the company, Rand's brilliant logo, and cutting-edge computer technology. Rand's logo became so well-known that even this rebus version, which humanized the monolithic company's image, was immediately understood.

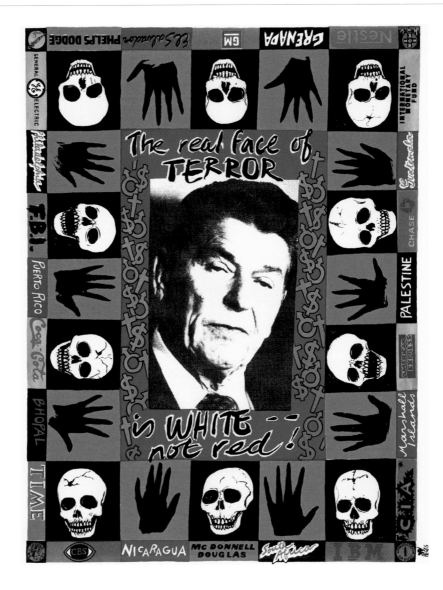

73

Jay Johnson
dates unknown

The Real Face of Terror
ca. 1985
26 × 20½ inches
Screen printing

PUBLISHER
Black Cat Prints
New York, NY

PRINTER
Unknown

The activism of the 1960s and '70s had faded, but President Reagan gave the left plenty to protest. Domestically, he gutted antipoverty programs, cut taxes on the wealthy and corporations, and ordered the largest military buildup in American peacetime history. Abroad, he took a hard line against communism, the "red terror." In this poster, Reagan is "the real face of terror," shown with regalia of virility, Christianity, and wealth. He controls an international chessboard showing bloody "moves" the U.S. has made, in cahoots with big business, including overthrowing communist governments (Grenada), supporting repressive regimes (South Africa), and conquest (Puerto Rico). Formed in the 1970s, Black Cat Prints was one of many little-documented poster collectives.

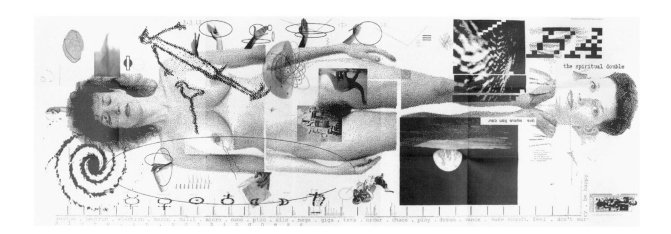

74

April Greiman
1948–

Does It Make Sense?
1986
25½ × 75¾ inches
Photolithography

PUBLISHER
MIT Press for
Walker Art Center
Minneapolis, MN

PRINTER
George Rice and Sons
Los Angeles, CA

Many designers felt that the impersonal, minimalist Swiss International style, dominant since the 1950s, had become formulaic. Greiman, a pioneer of the "new wave," embraced new technology as a means to innovate content and control production. Although many of her colleagues resisted the "chaotic" results, and believed that computers eliminated craft, Greiman made them reconsider when she turned a *Design Quarterly* issue into this two-sided poster. Created wholly on Macintosh, which debuted in 1984, the poster was aggressively personal and melded multiple-source, decontextualized imagery and idiosyncratic, diffuse typography into a highly-layered whole. This tour de force asserted that the new style and technology made *perfect*, albeit different, sense.

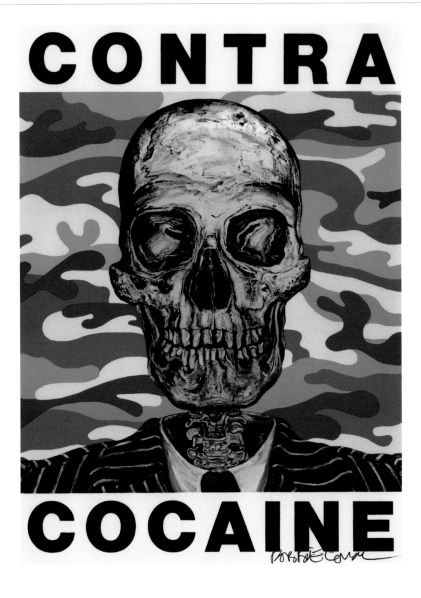

75

Robbie Conal
1944–

Contra Cocaine
1988
31¼ × 22¾ inches
Photolithography

PUBLISHER
Christic Institute
Washington, DC

PRINTER
Unknown

Robbie Conal's Art Attack,
http://www.robbieconal.com.

Determined to undermine the new Marxist regime in Nicaragua, the Reagan administration illegally funded, armed, and trained rebel Contras. This poster publicized allegations that the covert operation relied heavily on cocaine traffickers. Conal's wordplay emphasizes the hypocrisy of an administration "against" drugs yet knee-deep in Contra cocaine; and the "wanted poster" format underscores the operation's criminality.

The skeleton in a suit (set against Contra camouflage) evokes Day of the Dead traditions and José Posada's nineteenth-century caricatures of soulless, walking-skeleton politicians. Conal, trained as a fine artist, "makes posters of his paintings for a volunteer guerilla army to glue up [overnight] in every major city" in America.*

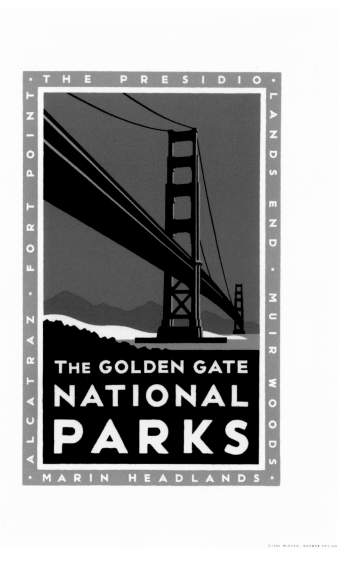

76

Michael Schwab
1952–

The Golden Gate National Parks
1995
30¾ × 22 inches
Screen printing

PUBLISHER
Golden Gate
National Parks
Conservancy
San Francisco, CA/
Michael Schwab Studios
San Anselmo, CA

PRINTER
Unknown

An esteemed designer as well as Bay Area resident, Schwab created a visual identity unifying the many Golden Gate National Parks. Scattered seventy miles to the north and south of the bridge, these disparate sites (not previously thought of as a whole) comprise an enormous urban preserve. This poster established the look of the eighteen-poster series: a strong, logo-like central image; vivid, screen-printed color reminiscent of WPA posters; dramatic perspective; and hand-drawn yet clean type. Forms are reduced to their essence–beautiful, timeless, highly legible. To reinforce that GGNP is a collection of sites, Schwab lists several of them along the poster's perimeter.

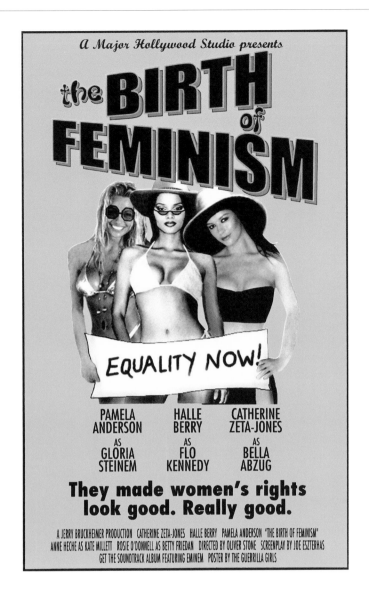

77

The Guerrilla Girls
active 1984–

The Birth of Feminism
2001
30 × 22 inches
Screen printing

PUBLISHER
Center for the Study
of Political Graphics
Los Angeles, CA

PRINTER
Unknown

Here is the Guerrilla Girls' satirical answer to "What would a Hollywood movie about feminism be like?" Sexed up, dumbed down, and as enlightened as the Klan-glorifying film *The Birth of a Nation*! Guerrilla Girls was formed in 1984 to expose discrimination persisting in the art world despite the gains of prior decades. The hard-hitting "girls" wore gorilla masks—maintaining the anonymity of artist and curator members—and used such tactics as "guerrilla postering" to help women and minorities crack into exclusionary museums and galleries. Meanwhile, their own well-publicized print work made graphic design that much less of a men's club. Successful, they have expanded into other countries and issues.

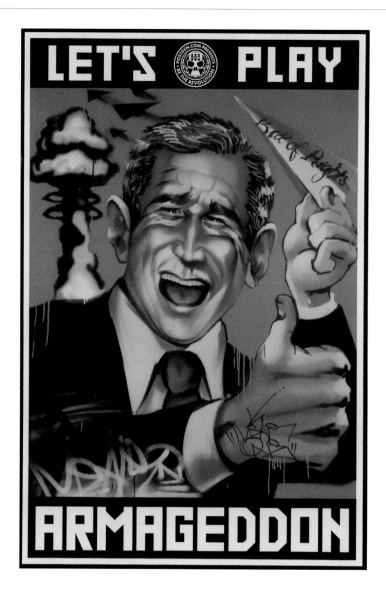

78

Mear One
1971–

Let's Play Armageddon
2004
36 × 24 inches
Photolithography

PUBLISHER
Post Gen

PRINTER
Typecraft, Inc.
Pasadena, CA

Following al-Qaida's September 11, 2001 attacks, President Bush launched the "War on Terror." His worldwide support was soon undercut by the Iraq invasion (based on highly-exaggerated claims of Saddam Hussein's threat), as well as the Guantanamo Bay detentions and Patriot Act, which many believed subverted the Geneva Convention and U.S. Constitution. Celebrated graffiti artist Mear One's work was part of a guerrilla postering campaign before the 2004 elections. With "thumbs up" and game-show-host grin, Bush says "just trust me." Meanwhile, he toys with the Bill of Rights and an atomic bomb explodes–his pre-emptive strike "game" portending Armageddon. Mear's graffiti aesthetic, including blood-red, dripping paint and a jolting palette, makes the image chaotic and frightening.

Nitin Sampat

Accurate color reproduction of the posters was achieved using a scientific approach from capture to print.

Nitin Sampat

One of the principal aims of this project was to investigate the feasibility of using a state-of-the-art digital press and an appropriate paper to produce a high quality, short-run color publication that would meet the exacting aesthetic and color reproduction standards of museums, libraries, and collectors. A digital workflow system was designed, and the entire production process, from image capture to printing, was carefully managed to ensure the most accurate reproduction of the subject matter. This research project involved faculty and students from RIT's College of Imaging Arts and Sciences, personnel from the Cary Graphic Arts Press, the print reproduction staff of RIT's Printing Applications Lab, and technical and materials support from HP and Mohawk Paper. The press was HP's Indigo 5000 and the paper was Mohawk's Superfine i-Tone.

Capture Process: The capture system utilized a high-resolution Betterlight digital camera back and Northlight studio lights. Uniform illumination and a neutral white balance was established for each poster. The characteristics of the camera and the lights were measured using scientific instruments such as spectro-radiometers and monochrometers. This combined information provided a means for quantifying the way in which the digital camera saw the color of the posters.

Reference Color Measurements: In order to determine how the human eye would see the same poster, a spectrophotometer (an instrument that can accurately measures color wavelengths) was used to measure a number of colors on every poster. This process was non-intrusive, and extreme care was taken to ensure that the poster was protected at all times.

Image Processing: The image processing was conducted using ARTIST, a proprietary software program developed at HP labs. The software mathematically compensated for any non-uniformity in the poster illumination and made corrections to compensate for the differences in how the camera and the human eye perceived color in the same poster. Each poster required its own unique correction, which was applied to the image to generate a colorimetrically-accurate image.

Paper Choice: Mohawk Superfine i-Tone 100-lb. text paper was selected for the project and generously donated by Mohawk Paper. This is a premium, archival uncoated paper with high opacity that minimizes show-through. Mohawk's i-Tone process provides for superior ink adhesion on an Indigo press.

Printer Characterization: The HP Indigo 5000 printer was characterized for its color capabilities (color gamut). The ink and paper combination was checked to ensure the presence of a wide color gamut for effectively rendering the colors of the posters.

Gamut Mapping: The processed color image was rendered into the gamut of the printer. This stage converts the captured RGB digital image into the Indigo CMYK printing space. A modest amount of sharpening was added to each image at this stage.

PDF Conversion: Each poster's CMYK file was placed into an Adobe InDesign book layout. The entire book file was subsequently converted to PDF at an output resolution of 812 dpi (the native resolution of the Indigo 5000). All compression and color management options were switched off in InDesign.

Proofing and Final Printing: All color management on the press was turned off, so that the PDF file could be printed with no processing on the printer side. Proof prints were compared to the originals under a D50 (5,000 degrees Kelvin) standard light source and approved, as necessary, for final printing in the edition run.

1	Edward Penfield	*Orient Cycles*	ca. 1895	42⅛	×	28⅜	31
2	Edward Penfield	*Harper's October*	1896	18¼	×	13¾	32
3	Louis J. Rhead	*The Century Magazine for June*	1896	21⅛	×	10⅞	33
4	Florence Lundborg	*The Lark for May*	1896	23⅞	×	13¹⁵⁄₁₆	34
5	Maxfield Parrish	*The Century*	1897	19¾	×	13	35
6	Joseph B. Hallworth	*Kar-Mi Swallows a Loaded Gun Barrel*	1914	28⅛	×	41⁹⁄₁₆	36
7	Clarence C. Phillips	*Light Consumes Coal*	1917	27⅞	×	20⁷⁄₁₆	37
8	James M. Flagg	*Be a U.S. Marine!*	1918	42¼	×	28	38
9	Adolph Treidler	*For Every Fighter a Woman Worker*	1918	40⅜	×	29	39
10	Hugo Gellert	*Vote Communist*	1924	22	×	13½	40
11	Designer Unknown	*Carter the Great*	1926	77⅝	×	41⅛	41
12	Designer Unknown	*Airplane Rides*	ca. 1929	37¹⁵⁄₁₆	×	25	42
13	Chesley Bonestell	*New York Central Building*	1930	40¹⁵⁄₁₆	×	26¹⁵⁄₁₆	43
14	Hernando G. Villa	*The Chief...is Still Chief*	1931	41½	×	28	44
15	James H. Minter	*Bal Papillon*	1931	19¾	×	14	45
16	Weimer Pursell	*Chicago World's Fair*	1933	41½	×	27⅜	46
17	Charles T. Coiner	*NRA We Do Our Part*	1934	27¾	×	20¾	47
18	Dorothy Waugh	*National Parks Winter Sports*	ca. 1934	40	×	27⅝	48
19	Dorothy Waugh	*National and State Parks*	ca. 1934	39¾	×	27⅜	49
20	William P. Welsh	*Pullman Safety & Comfort*	1936	27⁹⁄₁₆	×	21	50
21	Ben Shahn	*Years of Dust*	1936	38⅛	×	24¾	51
22	Robert Muchley	*Work with Care*	1937	24⅞	×	18⅝	52
23	Designer Unknown	*Poster Exhibit*	ca. 1937	22	×	14	53
24	Lester Beall	*Light*	1937	40	×	30	54
25	Lester Beall	*Wash Day*	1937	40	×	30	55
26	Nembhard N. Culin	*In 1939 The New York World's Fair*	1937	39¼	×	27⅝	56
27	Otis Shepard	*Catalina*	1938	39	×	51	57
28	Lester Beall	*Here It Comes*	1939	40	×	30	58
29	Lester Beall	*When I Think Back*	1939	40	×	30	59
30	Lester Beall	*Rural Electrification Administration*	1939	40	×	30	60
31	Joseph Binder	*New York World's Fair 1939*	1939	30¼	×	20	61
32	Louis B. Siegriest	*Indian Court*	1939	34	×	23	62
33	Albert M. Bender	*CCC A Young Man's Opportunity*	1941	27¹⁵⁄₁₆	×	14	63
34	Lester Beall	*Power on the Farm*	1941	40	×	30	64
35	Lester Beall	*A Better Home*	1941	40	×	30	65
36	Jean Carlu	*Production*	1941	29¹⁵⁄₁₆	×	39⅞	66
37	John Atherton	*Buy a Share in America*	1941	28	×	20	67
38	Leo Lionni	*Keep 'Em Rolling*	1941	40⅜	×	29¹³⁄₁₆	68
39	Herbert Matter	*America Calling*	1941	39⅞	×	29¾	69
40	Jean Carlu	*America Open Your Eyes*	1941	14	×	11³⁄₁₆	70
41	Joseph Binder	*Labor: Step into This Picture*	1941	13⅝	×	10¾	71
42	George Giusti	*Join A.R.P.*	1941	13½	×	10¼	72
43	Designer Unknown	*Official Civilian Defense Insignia*	1942	40	×	28½	73
44	Designer Unknown	*Women Work for Victory*	ca. 1942	26⅛	×	17⅞	74
45	Glenn Grohe	*He's Watching You*	1942	39¾	×	28⅜	75

ACKNOWLEDGMENTS

Thank you

The *American Image* exhibition was made possible through the cooperation of many individuals and departments at RIT, and most especially the College of Imaging Arts and Sciences (CIAS) which made its beautiful Bevier Gallery available for the display of these extraordinary posters and provided financial support. We are also grateful for the generosity of numerous benefactors, including members of the School of Design Advisory Board, who provided additional funding for the exhibit.

The publication of this catalog owes its existence to a committed team of RIT faculty, students, and staff in CIAS and its Printing Applications Lab (PAL), supplemented by critical assistance from additional friends of RIT. Working together with the Cary Graphic Arts Press, this team has helped to produce a landmark exemplar of digital printing technology with far-reaching implications for fine arts publishing. We are particularly grateful to our corporate partners at Hewlett-Packard and Mohawk Fine Papers for underwriting the materials costs of the catalog and all necessary technical assistance. Finally, special thanks to Nitin Sampat for leading the capture and image-processing team and Bruce Ian Meader for designing this catalog. All contributors to the exhibition and catalog not otherwise recognized in this publication are acknowledged below.

David Pankow, Director, RIT Cary Graphic Arts Press

Sponsors *for funding, facilities, and/or materials support*	**Contributors** *for installation, promotion, consultation, research, technical expertise, and/or production assistance*
Christopher K. Bailey, Class of 1980	Pamela Adams
Gene DePrez, Class of 1968	Miheer Bhachech
Judy Finlay, Hewlett-Packard	Frank Cost
William Garno, Director, RIT PAL	Patricia Cost
Lee D. Green, Class of 1974	Jeffrey DiCarlo
Christopher Harrold, Mohawk Fine Papers	Gary Dispoto
Robert D. & Willy Hursh	Adam Gordon
IBM Corporation	Michael Hansen
Patti Lachance, Chair, RIT School of Design	Kari Horowicz
Jim Malley, owner, Mercury Posters	Wei Koh
Deborah McKinzie	Tara Markert
John Meyer, HP Labs	Paul Matheson
James O'Hara, HP Boise Site	Lauren McDaniel
R. Roger & M. Suzanne Remington	Michael McGuire
Mark and Maura Resnick	Elizabeth Murkett
Joan Stone, Dean, CIAS	Mark Shaw
Stanley A. & Jacqueline Szymanski	Ingeborg Tastl